ON NOT BEING ABLE TO PAINT

ON NOT BEING ABLE TO PAINT

JOANNA FIELD
(Marion Milner)

Illustrated by the Author

Foreword by Anna Freud

J.P. TARCHER, INC.
Los Angeles
Distributed by Houghton Mifflin Company
Boston

Library of Congress Cataloging in Publication Data

Milner, Marion Blackett.
 On not being able to paint.

 Bibliography: p. 167
 Includes index
 1. Painting. 2. Creation (Literary, artistic, etc.)
I. Title.
ND1140.M5 1983 750'.1'9 83-582
ISBN 0-87477-263-X

J.P. Tarcher, Inc.
9110 Sunset Blvd.
Los Angeles, CA 90096

Manufactured In The United States Of America

P 10 9 8 7 6 5 4 3

*To my son and his generation
and may they not take as long
as I have in finding out about
these matters*

CONTENTS

PART V
THE USE OF PAINTING

APPENDIX

ILLUSTRATIONS

O Jerusalem! Jerusalem! I have forsaken thy courts,
Thy pillars of ivory and gold, thy curtains of silk and fine
Linen, thy pavements of precious stones, thy walls of pearl
And gold, thy gates of Thanksgiving, thy windows of Praise,
Thy clouds of Blessing, thy Cherubims of Tender Mercy,
Stretching their Wings sublime over the Little Ones of
Albion.
O Human Imagination! O Divine Body, I have crucifièd!
I have turnèd my back upon thee into the Wastes of Moral
Law:
There Babylon is builded in the Waste, founded in Human
desolation.
O Babylon! thy Watchman stands over thee in the night;
Thy severe Judge all the day long proves thee, O Babylon,
With provings of Destruction, with giving thee thy heart's
desire.

WILLIAM BLAKE

Concepts can never be presented to me merely, they must
be knitted into the structure of my being, and this can only
be done through my own activity.

M. P. FOLLETT, *Creative Experience*

FOREWORD

MARION MILNER'S treatment of psychic creativity differs in several respects from those well-established approaches to the subject to which psycho-analytic readers owe whatever familiarity with it they possess. She chooses as the object of her scrutiny not the professional and recognised artist but herself as a 'Sunday-painter'; not the finished masterpiece but her own fumbling and amateurish beginner's efforts to draw and paint. In short, she analyses not the mysterious and elusive ability of the genius who achieves self-expression through the medium of painting, but—as the title of the book suggests—the all too common and distressing restrictions by which the creativity of the average adult individual is held in check.

It is fascinating for the reader to follow the author's attempts to rid herself of the obstacles which prevent her painting, and to compare this fight for freedom of artistic expression with the battle for free association and the uncovering of the unconscious mind which make up the core of an analyst's therapeutic work. The amateur painter, who first puts pencil or brush to paper, seems to be in much the same mood as the patient during his initial period on the analytic couch. Both ventures, the analytic as well as the creative one, seem to demand similar external and internal conditions. There is the same need for 'circumstances in which it is safe to be absent-minded' (i.e. for conscious logic and reason to be absent from one's mind). There is the same unwillingness to transgress beyond the reassuring limits of the secondary process and 'to accept chaos as a temporary stage'. There is the same fear of the 'plunge into no-differentiation' and the disbelief in the 'spontaneous ordering forces' which emerge, once the plunge is taken. There is, above all, the same terror of the unknown. Evidently, it demands as much courage from the beginning painter to look at objects in the external world and see them without clear and compact outlines, as it demands courage from the beginning analysand to look at his own inner world and suspend secondary elaboration. There are even the same faults committed. The painter interferes with the process of creation when, in the author's words, he cannot bear the 'uncertainty about what is emerging long enough, as if one had to turn the scribble into some recognisable whole when, in fact, the thought or

mood seeking expression had not yet reached that stage'. Nothing can resemble more closely than this the attitude of haste and anxiety on the analyst's or patient's part which leads to premature interpretation, closes the road to the unconscious and puts a temporary stop to the spontaneous upsurge of the id-material. On the other hand, when anxieties and the resistances resulting from them are overcome, and the 'surrender of the planning conscious intention has been achieved', both —painter and analysand—are rewarded by 'a surprise, both in form and content'. It is at this juncture only that we meet the essential difference between the analytic process and the process of creation. The legitimate result of analysis is the inner experience of formerly unknown affects and impulses which find their final outlet in the ego-processes of verbalisation and deliberate action. The creative process in art, on the other hand, 'remains within the realm in which unknown affects and impulses find their outlet, through the way in which the artist arranges his medium to form harmonies of shapes, colours or sounds'; whether deliberate action is affected or not is the last issue, the main achievement is, according to the author, a joining of that split between mind and body that can so easily result from trying to limit thinking to thinking only in words.

Marion Milner's book is written throughout from the eminently practical aspect of self-observation and expression. Abstraction is relegated to an Appendix in which her theoretical opinions on creativity find expression.

Readers who have personal experience of any form of creative work, whether literary or artistic, will welcome the enlightening description of 'emptiness as a beneficent state before creation', and will acknowledge willingly, although shamefacedly, the truth of her brilliant explanation of the confusion in the creator's (especially an author's) mind between the orgiastic feelings during creation and the value of the created. Her treatment of this particular aspect of artistic productivity seems to me one of the most rewarding chapters of the book.

With regard to the analytic controversy whether psychic creativity seeks above all 'to preserve, re-create the lost object', the author takes the stand that this function of art, although present, is a secondary one. According to her, the artist's fundamental activity goes beyond the re-creation of the lost object to the primary aim of 'creating what has never been' by means of a newly acquired power of perception. There is, here, another correspondence with the results of analytic therapy.

For the patient too, we aim at more than mere recovery of lost feelings and abilities. What we wish him to achieve is the creation of new attitudes and relationships on the basis of the newly created powers of insight into his inner world.

There is, lastly, a highly interesting treatise on negativistic attitudes towards psychic creativity, in which certain inhibitions to create are ascribed to a fear of regression to an undifferentiated state in which the boundaries between id and ego, self and object, become blurred. Owing to this anxiety, no 'language of love', i.e. no medium can be found in which to 'symbolise the individual's pregenital and genital orgiastic experiences'. These views coincide in a welcome manner with certain clinical observations of my own concerning states of affective negativism, in which the patients' ability to express object-love is blocked by the fear of an all too complete emotional surrender. Future studies of this kind will owe much to Marion Milner's lucid explanation of this 'unconscious hankering to return to the blissful surrender, this all-out body giving of infancy'.

ANNA FREUD

INTRODUCTION

AFTER having spent five years in schools, busy with a scientific study of how children are affected by orthodox educational methods, and after the official results of that study had been published, I then found myself free to investigate certain private misgivings. They were misgivings which had begun to emerge during the course of the scientific work but which had not been clear enough or objective enough to have been put forward in a scientific report. They were concerned with the basic principles underlying the educational method, particularly in the sphere of what is usually called 'moral' education and also in sex education or the lack of it; they centred round a feeling that I needed a new set of ideas in thinking about these controversial questions. Although I felt there was a good likelihood that such matters were all connected with the problem of psychic creativity, whatever that might mean, I had not known at all how to take the first steps for studying them or even how to frame the pertinent questions. It was only gradually that a persisting idea had emerged that somehow the problem might be approached through studying one specific area in which I myself had failed to learn something that I wanted to learn.

Always, ever since early childhood, I had been interested in learning how to paint. But in spite of having acquired some technical facility in representing the appearance of objects my efforts had always tended to peter out in a maze of uncertainties about what a painter is really trying to do. Now the thought became more and more insistent that if only it were possible to find out how to set about learning to paint it should also be possible to find out the basic ideas needed for approaching the general educational problem.

This thought did not emerge out of nothing, it was in fact the result of a most surprising discovery, one of those happenings which seem to occur by inadvertence but which afterwards are recognised as marking a turning point in one's life. It was the discovery that it was possible at times to produce drawings or sketches in an entirely different way from any that I had been taught, a way of letting hand and eye do exactly what pleased them without any conscious working to a preconceived intention. This discovery had at first been so disconcerting that I had tried to forget all about it; for it seemed to

threaten, not only all familiar beliefs about will-power and conscious effort, but also, as I suppose all irruptions from the unconscious mind do, it threatened one's sense of oneself as a more or less known entity. But gradually I had had to force myself to face it, for it was clear that such a fact must undoubtedly have some bearing on those very educational assumptions which had aroused my misgivings. For instance, it might demand a revision of one's beliefs about the exact role of moral teaching, in so far as such teaching demands willed effort to live up to preconceived standards.

Not only did the way the drawings were produced seem to have a bearing upon the general educational problem but also their content. I did not at first see this, for although the actual technique of the drawings was often better than anything I had managed by deliberate effort, their subjects were usually phantastic, they were more concerned, I had thought, with psycho-analysis than with either painting or school methods. Bit by bit however it became clear that they were not only clues to unconscious 'complexes', they were a form of visual reflection on the basic problems of living—and of education; and being so, they were intimately connected, both in their content and their method, with the problems of creativity and creative process.

In the school study one of the problems raised had been to do with what line the staff should take in order to help the quiet over-introverted child who seems to have insufficient contact with the external world. It was through study of the experience of the free drawings that I came to understand more about the kind of problem that the over-introverted child is struggling with; and also, incidentally, what the over-extroverted child is running away from. Also in the school study, since the needs of large numbers of children had to be considered, it had seemed best to concentrate on the variety of ways in which different types of children seek to solve their difficulties. Thus certain aspects of the basic nature of everyone's problem in coming to terms with their surroundings had had to be taken for granted; there had been no time to enquire, for instance, into the processes by which any one of us comes to recognise the significant reality of our surroundings at all. But through the study of difficulties in painting I was to find that this question could no longer be ignored and that it was in fact closely bound up with a misgiving about something being left out of account in the general school system.

Although this issue was at first only dimly guessed at it did seem

likely that my enquiry into painting would lead to certain philosophical issues upon which many books had been written. But I decided to make no systematic attempt to read about these. This did not mean making no use of any philosophical writings that I had chanced upon, if they appeared relevant, it only meant not making any deliberate excursions into this field. This was because I vaguely suspected that whatever it might be that the misgivings were beckoning me on to investigate, it was not something that could be apprehended in the first instance by an intellectual approach. For this reason also it seemed best to try to record the stages of the investigation in as simple and direct a way as possible and not to venture beyond personal experience.

I also tried to avoid all books on aesthetic theory and the psychology of art and to confine my reading as far as possible to practical handbooks on the particular field of activity that I had chosen to investigate: that is, to handbooks on how to paint, written by painters.

The drawings were made variously in chalk, charcoal, watercolour, pen and ink, pencil. Since the aim of the book is to describe a personal experience centering round the drawings, not to put them forward as evidence in a scientific treatise, and since the book could not serve its purpose in the educational field if available only to the few, exactness of reproduction of the drawings has had to be sacrificed to ease of reproduction. For this reason there is only one coloured plate, although most of the originals were coloured, and some of the chalk or charcoal drawings have had to be turned into line drawings, by exact tracing. A description of the originals, giving medium, colours and size, is given at the end of the book.

M. M.

London, 1950

NOTE TO SECOND EDITION

THE FIRST edition of this book was planned primarily for teachers, and published in the Heinemann Education Series. The demand for a second edition has given me the opportunity of writing an appendix. In this I have attempted to state the basic problems raised in the book in terms of certain orthodox psycho-analytic concepts.

Anna Freud has also added a foreword to the second edition, for which I am extremely grateful. In it she has made a most illuminating comparison between some of the problems of the patient, in relation to his analyst, and the problems of the would-be painter in relation to his paper, paints and emerging picture.

Since the purpose of the book was to record a personal experience, in order to understand it, any major revision would be inappropriate. I have therefore let the original version stand, naïve though some of the attitudes expressed at the beginning may seem to me now.

In the introduction to the first edition I pointed out that the reproductions of some of the drawings were made from tracings of the originals. This would obviously be indefensible if the drawings were works of art, since the tracing process obliterates those subtleties of line upon which the vitality of a drawing depends. But these drawings are not put forward as works of art; they are intended to illustrate the gradual discovery both of ways by which the creative process is freed and of the content of unconscious ideas which interfere with that freedom.

It was not in fact until I had gone through the stages of discovery described in this book that I became able to see that what I had called 'free' drawings were most of them unfree. By this I mean that, though they were free in content, in the sense that the method of doodling, and making running comments while I doodled, had apparently made possible the free symbolic expression of unconscious ideas, yet they were not free in form. In most of them there was a rigidity of line (even in the originals) which was at once apparent to the eye of a perceptive painter.

I owe thanks to many friends and colleagues who read the manuscript of this book and helped with criticism and encouragement. Most particularly I wish to thank Dr. Sylvia Payne, Dr. D. W.

Winnicott and Dr. W. Clifford M. Scott; also Mrs. Peggy Volkov who edited the first edition. I am also very grateful indeed to Mr. Masud Khan who instigated the preparation and publishing of this second edition. For most valuable comments on the Appendix I wish to thank especially Mr. Anton Ehrenzweig, Mr. Heinz Koppel and Mr. Harold Walsby. I also wish to thank Mrs. Jeannie Cannon (in whose class the 'Mining Landscape' was painted) who first provided me with a social setting in which some of the discoveries I had made in solitude could be developed and tested in company with others. I also wish to thank Messrs. Longmans, Green & Co. for their permission to quote from M. P. Follett's *Creative Experience*. And finally, I owe a deep debt to Prof. M. Bohusz-Szyszko, in whose painting classes I have been able to begin the task of learning how my own observations, however small their scope, do make sense in the total setting of the difficulties facing both the modern European painter and the student of aesthetics.

M. M.

London, 1956

PART I

THE EMERGENCE OF THE FREE DRAWINGS
(Firing of the Imagination)

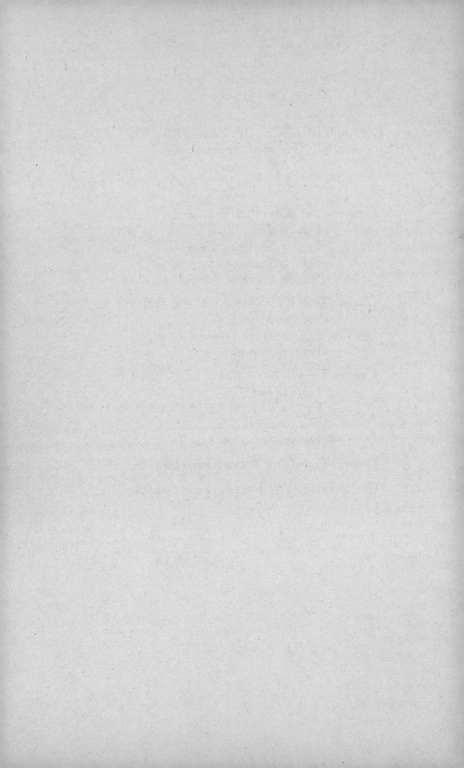

CHAPTER ONE

WHAT THE EYE LIKES

'O, down in the meadows the other day,
A-gath'ring flowers, both fine and gay,
A-gath'ring flowers, both red and blue,
I little thought what love could do.'

Folk Song

I HAD TRIED various obvious ways of learning how to paint, such as special painting lessons at school, evening classes in life drawing, sketching during holidays and visiting Art Galleries in the lunch hour and on Saturdays. But both the life drawings and the sketches were vaguely disappointing, they gave no sense of being new creations in their own right, they seemed to be only tolerably good imitations of something else; in fact, to be counterfeits.

Then I had begun to read books about the nature of the painter's problems. All the years previously I had painted blindly and instinctively, it was only discontent with the results that was the spur to trying to discover something about the technical problems the painter was trying to solve.

At first the books on how to paint seemed likely to provide help. They talked about the need for a sense of pattern in the arrangement of lines and masses, of darks and lights, about colour contrasts and harmonies, matters I had never deliberately thought about before. But the result of trying to put this new-found knowledge into practice was that anything done according to the learnt rules still had a counterfeit quality.

One of the books, however, said that the aim of painting was that the eye should find out what it liked. This seemed a useful idea, for it coincided with something I had already discovered about living many years since; a new world had then revealed itself as the result of an attempt, by keeping a diary, to find out what had seemed most important in each day's happenings. But as applied to drawing it was not so easy. One could see a tree that looked lovely, but in beginning to draw the sense of what the eye liked about it could disappear; indeed it often seemed not worth risking the attempt to draw, if with the first

3

few lines the sense of the loveliness might so vanish away. But one thing was quite clear. There was no doubt that drawings which were a fairly accurate copy of an object could produce an almost despairing boredom; so I was forced to the conclusion that copies of appearances were not what my eye liked, even though what it did like was not at all clear.

In another book I read that the essential of a good drawing was that the lines should be a genuine expression of a mood. Here was no reference to the object one was drawing, so it seemed a hopeful approach, it offered a possible way of breaking through this barrier of appearances. But when it came to the point of actually expressing a mood in lines and shapes it was a different matter. For instance, the books said that upright lines expressed dignity and power, horizontal lines restfulness, an upward curve exuberance, a sharp angle quick movement, a blunt angle slow movement. However true this might be it did not seem to help the expression of my own mood, there seemed to be no connection between moods as lived and anything that appeared on paper.

It was a long time before it occurred to me that one of the difficulties here might be something to do with a very careful selection of the moods to be depicted, an attempt to find expression for quiet and 'beautiful' ones only. This did not become apparent until after making my first surprising discovery.

Just as having once found that writing down whatever came into one's head, however apparently nonsensical, could reveal a meaning and pattern that one would never have guessed at, so I had now thought that drawing without any conscious intention to draw 'something' might also be interesting. The first attempts had not seemed to mean much and had no value as drawings. But one day, when filled with anger over a quarrel, I had turned to such free drawing in a desperate attempt to relieve the mood of furious frustration. Here is a note, made afterwards from memory, of what ideas had accompanied the actual process of drawing:

> Fig. 1: 'I'll have a large sheet of paper this time and charcoal, yes, it makes a good thick line . . . now . . . that's only a scribble, what's the good of that? It looks like a snake, now it's a serpent coiled round a tree, yes, like the serpent in the Garden of Eden, but I don't want to draw that, oh, it's turning into a head, goodness, what a horrid creature it is, a sort of Mrs. Punch, or the Duchess in Alice. How hateful she is with that hunched back and deformed hand and all that swank of jewelry.'

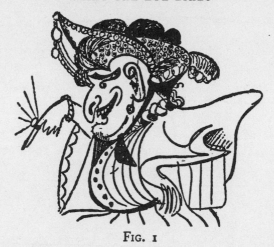

FIG. I

When the drawing was finished the original anger had all vanished. The anger had apparently gone into the drawing. So it seemed that here at least was an expression of a mood, even though it was not an original expression, but an unconscious adaptation of the Duchess in Lewis Carroll's famous book.*

This experience provided a first hint that some of the difficulties of achieving a genuine expression of mood might be due to the kind of mood seeking expression. One day, several years later, I saw a girl in an underground train, her toes turned in and a rapt, brooding expression which at once caught my attention. In herself she showed some of that inner intensity of living that always stirred the impulse to draw and I had read somewhere that one should always try to get at least something down on paper when such feelings occurred. On reaching home I had begun a sketch in charcoal, feeling that the mood to be expressed was a real aesthetic pleasure in beauty of form, to be embodied in a serious drawing of artistic worth. Instead, Figure 2 appeared.

Thinking over all this it occurred to me that preconceived ideas about beauty in drawing might have a limiting effect on one's freedom of expression, beauty might be like happiness, something which a too direct striving after destroys. But nearly all my drawings so far had been determined by a wish to represent beauty. I decided that the next time such a feeling occurred it would be worth trying some

* *Alice's Adventures in Wonderland* with John Tenniel's illustrations had been one of the most familiar books of my childhood.

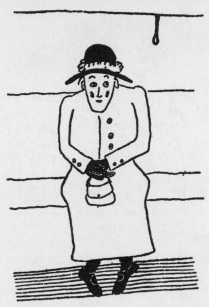

FIG. 2

experiments. So, when sitting in a buttercup field one Sunday morning in June, watching the Downs emerging from the mist, I checked the impulse to make a water-colour sketch which was certain to be a failure. Instead, I concentrated on the mood of the scene, the peace and softness of the colouring, the gentle curves of the Downs, and began to scribble in charcoal, letting hand and eye do what they liked. Gradually a definite form had emerged and there, instead of the peaceful summer landscape, was a blazing heath fire, its roaring flames leaping from the earth in a funnel of fire, its black smoke blotting out the sky (Fig. 3). This was certainly surprising, in fact it was so surprising it was hard to believe that what had happened was not pure accident, perhaps due to the fact that random drawing in charcoal easily suggests smoke. But the following week-end I was again urged to draw something beautiful, when sitting under beech trees on another perfect June morning and longing to be able to represent their calm stateliness. Once again I had tried the experiment of concentrating on the mood and letting my hand draw as it liked. After absent-mindedly covering the whole page with light and dark shadings I suddenly saw what it was I had drawn (Fig. 4). Instead of the over-arching beeches

spreading protecting arms in the still summer air, there were two stunted bushes on a snowy crag, blasted by a raging storm.

This, coupled with the heath fire drawing, suggested that the problem of expression of mood, so cheerfully disposed of in the instructions, was not so simple as it sounded; for it seemed very odd that thoughts of fire and tempest could be, without one's knowing it, so close beneath the surface in what appeared to be moments of greatest peace.

After this I found it was often possible to make drawings by the free method, even without the stimulus of strong conscious feeling

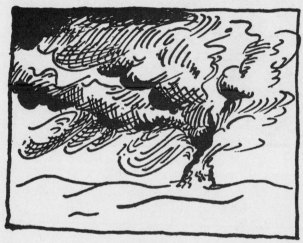

Fig. 3

about some external object. It was enough to sit down and begin to scribble and the scribble would gradually become a drawing of something. It was usually something rather phantastic, but not always; sometimes it was a single object, sometimes a dramatic scene, sometimes a surrealist conglomeration of bits. Occasionally it would remain just a scribble.

Also, although the drawings were actually made in an absent-minded mood, as soon as one was finished there was usually a definite 'story' in my mind of what it was about. Most often these stories had been written down at once but even when not so noted I could remember their exact details years after, they seemed to be quite fixed and definite, having none of the elusive quality of dreams. But I could |

not at this stage bring myself to face the implications of the fact, though recognising it intellectually, that the heath fire and blasted beeches and girl in the train drawings all expressed the opposite of the moods and ideas intended.

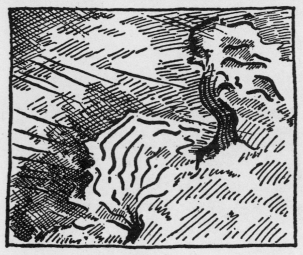

FIG. 4

BEING SEPARATE AND BEING TOGETHER

'The water is wide,
I cannot get o'er,
And neither have I wings to fly.
Give me a boat that will carry two,
And both shall row, my love and I.'
Folk Song

INSTEAD of trying to puzzle out the meaning of the free drawings I went on trying to study the painter's task from books. Up to now I had assumed that all the painter's practical problems to do with representing distance, solidity, the grouping of objects, differences of light and shade and so on were matters for common sense, combined with careful study. But when I tried to begin such careful study there seemed some unknown force interfering. Of course I was already familiar with the idea that one's common sense mind is not all there is, and that when it is difficult to do something that the common sense mind says is straightforward and should be done, then one must expect the imaginative mind to have quite other views on the matter. But I had not up to now thought of applying this to painting. When I did, it was clear that the imaginative mind could have strong private views of its own on the meanings of light, distance, darkness and so on. For instance, I began to find that it had some very definite ideas of its own about the subject of perspective and that these ideas were in fact being illustrated in some of the drawings.

In spite of having been taught, long ago at school, the rules of perspective, I had recently found that whenever a drawing showed more or less correct perspective, as in drawing a room for instance, the result seemed not worth the effort. But one day I had tried drawing an imaginary room (Fig. 5) and after a struggle, had managed to avoid showing the furniture in correct perspective. The drawing had been more satisfying than any earlier ones, though I had no notion why. Now it occurred to me that it all depended upon what aspects of objects one was most concerned with. The top of a table, for instance, could be considered as a supporting squareness on which

9

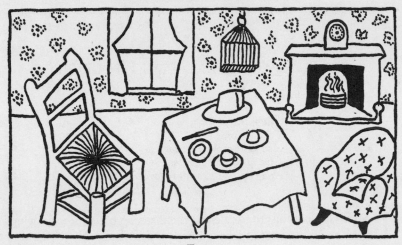

Fig. 5

to lay the breakfast, not as a flattened shape with side-lines fading off to a vanishing point, as it seems to the contemplative eye when one sits down to make a sketch of it. And so with chairs, the important thing about a chair seemed to be that it is below one, ready to support one's weight; and that was how I wanted to draw it. Gardens introduced a similar question of view-point; I found I wanted to draw a garden looking down on it from above, so that one was, as it were, more nearly inside it and surrounded by it (Fig. 6). It was as if one's mind could want to express the feelings that come from the sense of touch and muscular movement rather than from the sense of sight. In fact it was almost as if one might not want to be concerned, in drawing, with those facts of detachment and separation that are introduced when an observing eye is perched upon a sketching stool, with all the attendant facts of a single view-point and fixed eye-level and horizontal lines that vanish. It seemed one might want some kind of relation to objects in which one was much more mixed up with them than that.

At first I thought that such an unwillingness to face the visual facts of space and distance must be a cowardly attitude, a retreat from the responsibilities of being a separate person. But it did not feel entirely like a retreat, it felt more like a search, a going backwards perhaps, but a going back to look for something, something which could have real value for adult life if only it could be recovered. It

almost seemed like a way of looking at the world which the current, 'reasonable', common sense way had perhaps repudiated, but a way which might have potentialities of its own at the appropriate time and place, a kind of uncommon sense that one needed.

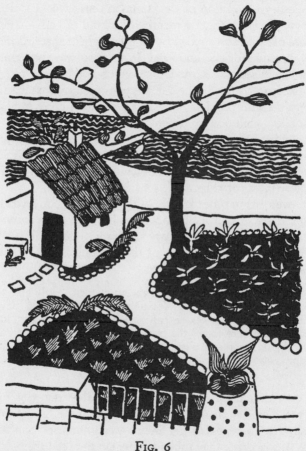

FIG. 6

Somewhere in the books it was stated that painting is concerned with the feelings conveyed by space. This was surprising at first, up to now I had taken space for granted and never reflected upon what it might mean in terms of feeling. But as soon as I did begin to think about it, it was clear that very intense feelings might be stirred. If one saw it as the primary reality to be manipulated for the satisfaction of

all one's basic needs, beginning with the babyhood problem of reaching for one's mother's arms, leading through all the separation from what one loves that the business of living brings, then it was not so surprising that it should be the main preoccupation of the painter. And when I began to feel about it as well as think about it then even the whole sensory foundation of the common sense world seemed to be threatened. For instance, I remembered a kind of half-waking spatial nightmare of being surrounded by an infinitude of space rushing away in every direction for ever and ever. In a similar way the term 'vanishing point' aroused vistas of desolation. So it became clear that if painting is concerned with the feelings conveyed by space then it must also be to do with problems of being a separate body in a world of other bodies which occupy different bits of space: in fact it must be deeply concerned with ideas of distance and separation and having and losing. What I did not yet see was that the free drawings which had been set aside were all the time silently showing what the feelings about those ideas could be.

There were many other aspects of the emotions conveyed by space to be considered. For instance, once you begin to think about distance and separation it is also necessary to think about different ways of being together, or in the jargon of the painting books, composition. On this subject I read:

> 'Looking at any single object the spectator is easily able to decide; "Yes, that is a nice shape" (or ugly shape as the case may be). In selecting another object he can also decide; "This, too, has a nice shape." But here comes the test of the artistic vision. In placing the two objects together in a group is he able to decide whether the group-shape is also nice?'
>
> Jan Gordon: *A Step Ladder to Painting*, p. 45

My own experience certainly confirmed that this test of artistic vision was a crucial one. I found that to draw the line of one object with fully felt awareness of the line of a neighbouring one and of the patterns of space that they mutually created between them, seemed as potent an act as laying a wire across the terminals of a battery; and the resulting flash seemed to light a new world of possibilities. Presumably it was fear of these new possibilities which caused such a compelling narrow focus of attention in which it was only possible to attend to one thing at a time. One drawing certainly illustrated the curious lengths this narrow focus could lead to (Fig. 7). It was not a free drawing but a deliberate attempt at imaginary composition and at first

it was not at all clear why two of the houses were at right angles to the slope of the hillside; the drawing defied the elementary facts of gravity and yet I had felt a determined impulse to draw it like that. But now it seemed likely that it was a matter of narrow focus, the two end houses were thought of so much in isolation that each had its separate

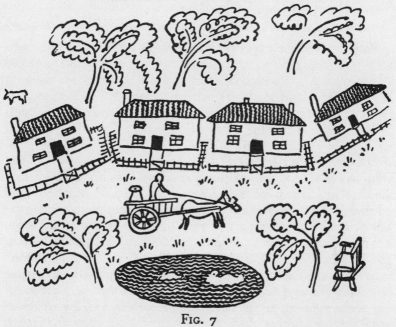

FIG. 7

base-line of earth regardless of the fact that it was 'together with' other items in the picture.

The more I thought about the direction in which this study was leading the more one thing seemed likely: that original work in painting, if it was ever to get beyond the stage of happy flukes, would demand facing certain facts about oneself as a separate being, facts that could often perhaps be successfully by-passed in ordinary living. Thus it seemed that it was possible, in spite of having lived a life of independent work and travel and earning a living, to have evaded facing certain facts about the human situation, or only given a superficial acquiescence to them. Otherwise why was it so difficult to feel about, as well as think about, the separateness or togetherness of objects? As a matter of fact the painters themselves, some of them,

seemed willing to admit that genuine vision as an artist needed a kind
of courage that was willing to face all kinds of spiritual dangers. For
I remembered Samuel Palmer's account of a conversation with Blake,
then sixty-seven years old and busy upon his Dante designs.

> 'He said he began them with fear and trembling,
> I said, "O! I have enough of fear and trembling."
> "Then," said he, "you'll do." '
> A. Gilchrist: *Life of Wm. Blake*, p. 390

But what were these spiritual dangers? Certainly seeing with one's
own eyes, whether in painting or in living, seeing the truth of people
and events and things needed an act of the imagination; for the truth
was never presented whole to one's senses at any particular moment,
direct sensory experience was always fragmentary and had to be com-
bined into a whole by the creative imagination. Even the perception
of a chair or a carrot was an imaginative act, one had to create imagina-
tively, out of one's past experience of walking round things or holding
them in one's hand, the unseen other side of the chair or the carrot.
And how much more did one have to create the insides of things. And
when the solid object was a living person, what great feats of imagina-
tion even the most unimaginative person achieves in recognising them,
not only as solid bodies with physical things inside, bones and nerves
and blood and so on, but also as having their past and their future
inside, memories and hopes and ideas. The present-moment view of
any object is always determined by the accident of where one is stand-
ing at the moment, as the view of a person's face is, the accidental
angle that the snapshot often catches with violently distorting results.
But to know the truth of people you have to select and combine; to
grasp the essence of them, whether in paint or thought, you have
surely to combine all the partial glimpses into a relevant whole. This,
however, since it requires imagination, brought me face to face with
certain dangers inherent in the nature of imagination.

OUTLINE AND THE SOLID EARTH

'. . . there they hoist us,
To cry to the sea that roar'd to us; to sigh
To the winds, whose pity, sighing back again,
Did us but loving wrong.'

Shakespeare

IT WAS through the study of outline in painting that it became clearer what might be the nature of the spiritual dangers to be faced, if one was to see as the painter sees.

Up to now it was the outline that had seemed the easiest thing to manage. Apparently this is a common belief, for I read:

'Most of the earliest forms of drawing known to us in history . . . are largely in the nature of outline drawings. This is a remarkable fact, considering the somewhat remote relation lines have to the complete phenomena of vision.'

Harold Speed: *The Practice and Science of Drawing*, p. 50

The last remark in this passage was surprising, for I had always assumed in some vague way that outlines were 'real'. I read on:

'. . . a line seems a poor thing from the visual point of view: as the boundaries (of masses) are not always clearly defined, but are continually merging into the surrounding mass and losing themselves, to be caught up again later on and defined once more.'

After reading this I tried looking at the objects around me and found that it was true. When really looked at in relation to each other their outlines were not clear and compact, as I had always supposed them to be, they continually became lost in shadow. Two questions emerged here. First, how was it possible to have remained unaware of this fact for so long? Second, why was such a great mental effort necessary in order to see the edges of objects as they actually show themselves rather than as I had always thought of them? Then I read:

'. . . the outline is the one fundamentally unrealistic non-imitative thing in this whole job of painting. Colours generally try to reproduce the effects of nature, tones and shadows also do their best. But outline

15

the foundation of all drawing ... is in truth no more than a bold
artistic dodge. ...

'Wild beasts such as the tiger or the zebra show how elusive the
outline can become. A few black stripes on the tiger's hide, and he no
longer is

> Tiger! Tiger! burning bright
> In the forests of the night,

but merely a part of the sunlight and shadow of an Indian jungle. All
his terror, malice and majesty have been swallowed up in a mere light
effect. *The outline puts him in his place.*'

Gordon: *A Step Ladder to Painting*, p. 18

The italics are mine and this seemed the crux of the matter. For I
noticed that the effort needed in order to see the edges of objects as
they really look stirred a dim fear, a fear of what might happen if one
let go one's mental hold on the outline which kept everything separate
and in its place; and it was similar to that fear of a wide focus of
attention which I had noticed in earlier experiments.

After thinking about this I woke one morning and saw two jugs
on the table; without any mental struggle I saw the edges in relation
to each other, and how gaily they seemed almost to ripple now that
they were freed from this grimly practical business of enclosing an

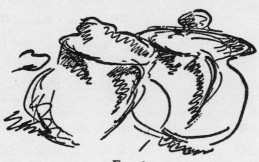

FIG. 8

object and keeping it in its place. This was surely what painters meant
about the *play* of edges; certainly they did play and I tried a five-
minute sketch of the jugs (Fig. 8). Now also it was easier to under-
stand what painters meant by the phrase 'freedom of line' because here
surely was a reason for its opposite; that is, the emotional need to
imprison objects rigidly within themselves.

When trying to think about what might be the reason for this need

to make objects keep themselves to themselves within a rigid boundary I remembered reading:

> 'The outline is . . . the first and plainest statement of a tangible reality.' Gordon: *A Step Ladder to Painting*, p. 19

Thus the outline represented the world of fact, of separate touchable solid objects; to cling to it was therefore surely to protect oneself against the other world, the world of imagination.

So I could only suppose that, in one part of the mind, there really could be a fear of losing all sense of separating boundaries; particularly the boundaries between the tangible realities of the external world and the imaginative realities of the inner world of feeling and idea; in fact a fear of being mad. This same fear was to appear again in connection with the imaginative perception of action in nature, the fear that letting go common sense appearances and letting in imagination meant letting in madness. I wondered, perhaps this was one reason why new experiments in painting can arouse such fierce opposition and anger. People must surely be afraid, without knowing it, that their hold upon reason and sanity is precarious, else they would not so resent being asked to look at visual experience in a new way, they would not be so afraid of not seeing the world as they have always seen it and in the general publicly agreed way of seeing it.

The extent to which one's mind could be concerned with this question of boundaries was again apparent when I looked at some diary notes made on a summer holiday. It was the summer after most of the free drawings had appeared and the notes had been made in an attempt to come to grips with the problem of realism in painting. They had grown out of a determination to break away from the dull, realistic, impressionist type of amateur landscape painting, a determination to try to state pictorially something of the inner brooding quality of nature, rather than her accidental appearances. But I had no notion how or where to begin, I could not even decide what bit of nature to paint, much less how to paint it. So it had been in desperation that I had decided not to paint at all but to try to record in words, with perhaps brief pencil sketches, the faintest indications of what the eye seemed to like.

August 5th, 1939. I wanted to paint the approaching storm and thundery light, looking out from East Head over Thorney Isle. There was green water darkening towards the horizon and looming sky much darker than the sea. In the foreground, waves glistening white against

the green, white sand close inshore, some terns, whiter than all against the darkening sea.

But since I could not manage to paint to that extent I tried drawing freely from the memory of it, in charcoal, and found I had made the thunder bird of the New Mexican Indians, spreading right across the sky, also a huge shadowy Indian drum and a snake rising up out of the sea (Fig. 9).

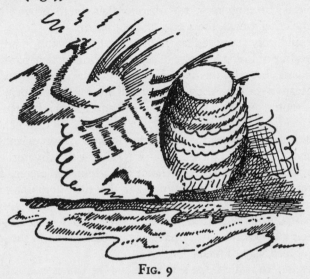

FIG. 9

August 7th. I wanted to draw the tensions and sweep of 'earth' by the shore, not outline or edge so much as stretch and spread and heave of the sea-wall and low shore cliffs—yet seen in terms of line. What about colours, colours of earth? I did not notice them, except the crimson brown of the saltmarsh plants, but as I think of it now the colours grow and deepen in my thought, ochres and umbers and viridian put on thick. Earth, it's dark, full of body, not the sunny pale surface of a water-colour. But why can't I settle down to paint?

August 9th. Still I want to paint these earth colours, under a heavy sky, wet short grass, ragwort, green and yellow. I've tried making little water-colour notes of colour combinations but water-colour used like that seems to lack vitality, no glow in it. I want to make colours lit from within. On this cloudy day after rain wet grass glows its greenness from inside itself.

How the crisp froth of a wave gets narrower as it gets nearer the shore and the nearest one shows the yellow of sand through the water!

August 17th. Still this desire to paint 'earth' but I can find no special corner of it that will make a picture. So I have tried doing free drawings

to see what this thought of earth means, I have done a series of four (Fig. 10 *a, b, c, d*) but they are hardly more than scribbles, and I don't know what they mean.

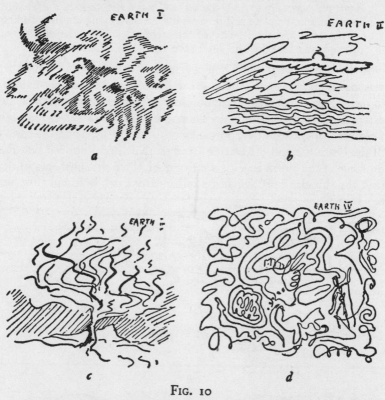

FIG. 10

August 26th. I did find something to draw, a bit of the sea-wall. Now I have done about half a dozen line sketches of it, only about ten minutes each, it seems a very small bag for three weeks' effort, but I have found something about what the eye likes: for the first one (Fig. 11 *a*) is just a copy of the scene, quite realistic but not what my eye wants, the others seem to be gradually simmering out the essence of the form, the swerving stone groyne which seems to become utterly different when the accidental details are forgotten (Fig. 11 *b*).

August 27th. When I woke up this morning I suddenly thought that it's the sea-gate in the wall that I have been drawing, where the seas broke in last winter and flooded the marshes, right up to and over the meadow. Now I see how those free drawings on the theme of earth led up to this: for two show chaos, or very nearly, and one shows a bird over a waste of waves, like Noah's Dove who went out to seek for solid

ground and also like the spirit brooding over the face of the waters, over the primary chaos. And one is a tree on a bare mountain, the beginnings of land emerging from the flood. Yes, I am sure this is why I wanted especially to draw the sea-wall, a firmness to keep the flood of something in its place and prevent it from destroying the firm outline of the earth and the fertility of the pasture. And yet the thought of that inrush of the tide that broke the sea-wall is full of richness.

In spite of having been half aware that there might be internal reasons for choosing the broken sea-wall as subject, it was not obvious, to me at least, what was the significance of the other small bits of the external world that appeared in the notes. For instance, I did not see a connection between the approaching storm of Fig. 9 and the theme of the heath fire and the blasted beeches. Nor had I noticed that the drawing of the storm in Fig. 9 introduced phantastic elements in the sky, the thunder bird and huge Indian drum, while leaving the sea

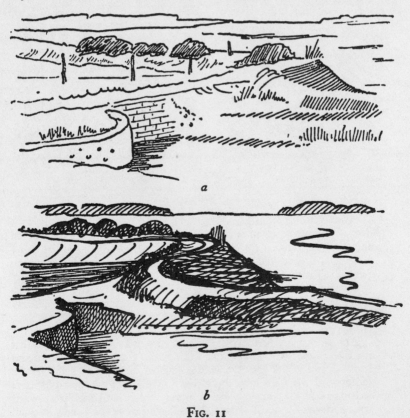

a

b

FIG. 11

drawn in a representational way. Having failed so far to apply Blake's remark 'That which is above is within' to these drawings, I had not yet arrived at the idea that the whole holiday could have been dominated by a single problem: the struggle to bring into relation the dream imaginings up above (inside) and the solid realities of the external world. For the same reason it had not been obvious what was the point of those free drawings on the theme of 'Earth' that had turned out to be hardly more than chaotic scribblings; for it had not as yet become apparent that the very problem so insistently trying to draw attention to itself was something to do with achieving a relation to the inevitable 'otherness' of what is outside one, to the reality of the solid earth. I did realise, however, that the Noah's Dove drawing represented a state of mind I was familiar with; one in which, although the world around was quite clearly and precisely 'there', yet it remained utterly remote and meaningless, there was nothing in it to rest upon or clutch hold of.

It was, however, the exact opposite of the ideas symbolised by the Noah's Dove drawings which eventually pointed the way to understanding something of what might be happening here.

They were experiences to do with the observation that at times, by the way in which one looked at a thing, it was possible to bring about an intense feeling for and belief in its living reality. Such a way of looking brought a complete transfiguration of the common sense expedient view where objects, both people and things, existed mainly in terms of their usefulness; it brought a change to a world of living essences existing in their own right and offering a source of delight simply through the fact of being themselves. In short, it was a transfiguration comparable in a small way to the transfiguration of falling in love; but, although such a vital experience, it was something that often for months together never happened. Because of this it could leave one vaguely preoccupied and continually searching for its return, discontented with the common sense world but also vaguely resentful that such moments could so interfere, by their contrast, with the common sense pleasures of living. And all the time one could have a lurking doubt whether this view of the world might not be somehow more real than the common sense one.

It was through attempts to study the use of colour that it became clearer what was the next direction in which to explore, both in order to understand more about the questions of outline and also of this divided allegiance between the two ways of looking.

THE PLUNGE INTO COLOUR

'O more than Moone,
Draw not up seas to drowne me in thy sphere,
Weepe me not dead, in thine arms, but forbeare
To teach the sea, what it may doe too soone.'
John Donne, 1572–1631

COLOUR in painting had been a subject which for years I had been quite unable to think about. It was as if it had been so important that to think about it, to know just what one was trying to do with one's paints, had been to risk losing something; it seemed at first glance as if an experience so intimate and vital must be kept remote and safe from the cold white light of consciousness which might destroy its glories. In fact it was as if colour and the light of knowing were differences which must be kept firmly separate, just as objects had to be kept separated and not seen in their mutual effect upon each other. So, up to now I had used paint blindly and the results had only on rare occasions been satisfactory.

When I did eventually arrive at trying to learn something about the deliberate use of colour it was again after attempting to follow instructions from the books. For instance, I read that in order to learn how to manage paint it was best to begin with a still-life; two objects were to be arranged against a simple background and to be drawn in a heavy line with brush and Indian ink. But when I had tried a still-life of this kind there was nothing in the result to suggest that it had been worth doing; and when, instead of trying to follow instructions, I set about observing what the eye liked, in the way of colour experiences, the result was a quite opposite conclusion about the way to use colour.

These observations about colour began when, on looking through some earlier attempts at landscape, I noticed that the only glimmer of interest came where there was a transition of colour; for instance, where the yellow lichen on a barn roof had tempted me into letting the yellows and reds merge, unprotected by any felt division, so that you could not say exactly where one colour began and another ended. Also I noticed that a smear of paint left on the palette after painting,

22

where white merged into red, blue, brown, was interesting and alive; whereas the picture painted with the same colours but carefully separated by felt lines was dead. And another hint had come from looking at a roof painted with a tiny streak of blue in the shadow. There had certainly been no blue in the colour of the actual roof; yet this touch of a colour that was not there was the most vital thing in the picture. After noticing this fact I forgot it again; but some time later, having decided that the old sketches were not worth preserving so they might as well be used for experiments, I had taken one of a church and begun to repaint it, choosing the colours without any thought of how the tower and trees and roof had looked at that particular place on that particular day. When it was finished the light, which in the original version had been an attempt to take into account the actual position of the sun on an afternoon in August, now glowed up from the ground at the foot of the church tower in a quite impossible manner, it spread warm colours over the grey stone that had never been there at all. Then I had tried freely painting over another sketch, one of a village with a haystack in the foreground; and the result was that the original lamely copied yellow of the haystack lit by pale September sun had become something on fire from within with colour that spread up over the whole village.

In both these re-paintings the light seemed to come from the earth rather than from the sky, and the colour also flooded up from the earth, once it was let loose from bondage to natural appearance and outline.

Then I began to notice something else. Although finding it very difficult to paint a whole picture I had for a long time been making mental notes of colour impressions. One evening on a summer holiday, I had recalled the colour of the grass-edge between stubble field and sea-shore, the mixed pale green and creamy yellow of sun-bleached August grass; and as I watched the memory of the colour it had seemed to change and grow in vividness. After this, I had tried to observe colour impressions more closely and make written notes.

'How colours in nature alter when I shut my eyes; they seem to grow and glow and develop. It looks as if colour ought to be very free to develop in its own way from the first impression—and it needs time, willingness to wait and see what it does. Yet in saying this I have a flicker of fear, fear of where it may go with no checks, no necessity to copy exactly the colour of the object as it seems at first sight. I think I have been trying to hold it down to a formula, painting a green tree green, with light and darker bits, yes, but essentially green

—afraid to let other colours flow in—and yet the only exciting bits are when the colours are split, making a sort of chord so that they seem to move and live against each other—certainly the flat matching of colour to the object, saying "Is this green the same as that green of the tree?" produces a terribly dead effect.'

This feeling of colour as something moving and alive in its own right, not fixed and flat and bound like the colouring of a map, grew gradually stronger. Again and again it happened that when I closed my eyes and tried to recall colour combinations seen in nature, the memory did grow and glow and develop in the most surprising way. So here was a meeting of the conscious inner eye and the blind experience of colour which resulted from the willingness to watch and wait. And it was a meeting which neither destroyed the dark possibilities of colour nor dimmed the light of consciousness; in fact it produced a new and vital whole between them, and one which seemed to glow up from the depths of one's existence, like the light in my sketches which had flooded up from the earth. But in spite of this discovery I still found it very difficult to achieve this watching and waiting, part of my mind still wanted to keep colour firmly within boundaries and staying the same.

Here also were certainly two different ways of feeling about experience. One way had to do with a common sense world of objects separated by outline, keeping themselves to themselves and staying the same, the other had to do with a world of change, of continual development and process, one in which there was no sharp line between one state and the next, as there is no fixed boundary between twilight and darkness but only a gradual merging of the one into the other. But though I could know, in retrospect, that the changing world seemed nearer the true quality of experience, to give oneself to this knowledge seemed like taking some dangerous plunge; to part of my mind the changing world seemed near to a mad one and the fixed world the only sanity. And this idea of there being no fixed outline, no boundary between one state and another, also introduced the idea of no boundary between one self and another self, it brought in the idea of one personality merging with another. Here I could not help remembering what Cézanne is reported to have said about looking at a picture:

'The part, the whole, the volumes, the values, the composition, the emotional quiver, everything, is there ... Shut your eyes, wait, think of nothing. Now, open them ... One sees nothing but a great coloured undulation. What then? An irradiation and glory of colour.

That is what a picture should give us, a warm harmony, an abyss in which the eye is lost, a secret germination, a coloured state of grace. All these tones circulate in the blood, don't they? One is revivified, born into the real world, one finds oneself, one becomes the painting. To love a painting, one must first have drunk deeply of it in long draughts. Lose consciousness. Descend with the painter into the dim tangled roots of things, and rise again from them in colours, be steeped in the light of them.'

J. Gasquet: *Cézanne*

This idea of the very eye which sees being lost, drowned in the flood of colour, sounded all right, as long as it was a coloured state of grace and one did rise again. But supposing one did not? And supposing that it was not a picture but a person that was loved like this? As yet I could not see very far along this way, but later it was to become clear that some of the foreboded dangers of this plunge into colour experience were to do with fears of embracing, becoming one with, something infinitely suffering, fears of plunging into a sea of pain in which both could become drowned. At present, however, I only knew that there was some unknown fear to be encountered in this matter of colour and the plunge into full imaginative experience of it.

Persistent following up of any clue to what the eye liked had then led to this: to having to face the fact of a warmth and a glow and a delight flooding up from within, dictated by no external copy but existing and developing and changing in its own right, as a result of one's own awareness of the developing relation between oneself and what one was looking at. But at the same time the dispensing with an external copy brought dangers of its own. Certainly it seemed that as long as one is content to live amongst the accepted realities of the common sense world, the fear of losing one's hold on the solid earth may remain unrecognised; but that as soon as one tries to use one's imagination, to see with the inner as well as with the outer eye, then it may have to be faced. I say 'may' because obviously there are some people for whom ventures into the world of imagination are not beset with dangers, or, at least, not always. I remembered Bunyan's description of the valley of the Shadow of Death, how some saw in it:

' . . . hobgoblins, satyrs, dragons of the pit.'

While Faithful's report was that for him the sun had shone all the way.

THE NECESSITY OF ILLUSION

'Twice or thrice had I loved thee,
Before I knew thy face or name.'
John Donne

IT NOW looked as if some of the spiritual dangers to be faced in this matter of coming to see as the painter sees were concerned with the transfiguration of the external world; in fact, with a process of giving to it something that came from within oneself, either in an overwhelming or a reviving flood. Also this process could be felt as a plunge— a plunge that one could sometimes do deliberately but which also sometimes just happened, as when one falls in love. But although the mechanism seemed to be a giving out of something from within oneself and the experience of such a giving could feel like a plunge, I could not understand at first what it was that one gave; also I did not know the difference between this intense kind of feeling about something one was looking at and the more ordinary ways of looking, I did not know whether it was a difference of kind or only of degree. But then I chanced to read something which did seem to throw light on what might be happening. It suggested that the bit of oneself that one could give to the outside world was of the stuff of one's dreams, the stored memories of one's past, but refashioned internally to make one's hopes and longings for the future.

The passage was, in fact, written, not by a painter but by a philosopher, and the writer's position in philosophy appeared to have an idealist bias which would not be entirely appropriate to my particular needs.* But as pure description what I read did fit in with what seemed to happen in this matter of coming to feel the significant reality of the external world.

'Perception is no primary phase of consciousness: it is an ulterior function acquired by a dream which has become symbolic of its own

* Since my professional work was a branch of biology, it was difficult to adopt entirely any philosophical standpoint which either, on the one hand, denied that the organism exists in a real environment; or, on the other hand, denied, as the mechanist view does, the importance of the organism's capacity for being aware of that environment.

external conditions, and therefore relevant to its own destiny.' Santayana: *Little Essays*, 'The Suppressed Madness of Sane Men'.

In the first flash of reading this I had felt it was right. But then I wondered, what could the writer mean by saying the dream comes first and is the primary phase of consciousness; for a dream must be of something, there must have been something there to start with to dream about. Then I thought the answer was that the first phase of experience is a dream rather than a perception simply because we are not born knowing the difference between thoughts and things, not born knowing the difference between subjective and objective, it is a knowledge only slowly acquired. Thus at first, although we are already experiencing the difference, finding that our pangs of hunger are only stilled when there is a real person there to feed us, we are not yet aware of it. Our experience is as yet a wholeness in which subject and object are still united, in which the breast that satisfies us and the hunger that it satisfies are a mystical unity. But if so, then how did this experience of wholeness and the memory of it which then became the desire for its repetition, how did this ever develop into perception? How did we ever come to realise that there was an external reality which could alone make the dream come true again, how did we take the momentous step of knowing that what we hunger for is a reality outside ourselves? In Santayana's words, how does our dream become symbolic of its external conditions, how do we ever come to feel that our mother's breast and all the later sources of life are relevant to our destiny? Certainly in the Noah's Dove state of mind nothing seemed relevant to mine. But I read further:

'Such relevance and symbolism are indirect and slowly acquired: their status cannot be understood unless we regard them as forms of imagination happily grown significant.'

Yes, happily grown significant, that was surely the point, implying that it did not always occur and that any of us may possibly at times relapse into a state of mind where that precarious achievement is lost, where we lose the power to endow the external world with our dreams and so lose our sense of its significance. For I read on:

'In imagination, not in perception, lies the substance of experience, while science and reason are but its chastened and ultimate form.'

Thus the substance of experience is what we bring to what we see, without our own contribution we see nothing. But I wanted to add

that of course imagination itself does not spring from nothing, it is what we have made within us out of all past relationships with what is outside, whether they were realised as outside relationships or not. I thought that Santayana's sentence did not mean that thought actually starts first and is more 'real' than things (though I knew some philosophers believed this) but that our inner dream and outer perception both spring from a common source or primary phase of experience in which the two are not distinguished, a primary 'madness' which all of us have lived through and to which at times we can return. And this also was, I thought, why Santayana could say:

> 'Sanity is a madness put to good uses, waking life is a dream controlled.' 'The Elements of Poetry', *op. cit.*, p. 146

Such statements, although in contrast to so much of the generally accepted views of our relation to the world, did give a meaning to certain most vivid experiences which up to now I had never known how to explain. They threw light, for instance, on the persistent feeling about parts of the country that I loved most, that these were haunts of the gods, places where indefinable presences were about. They threw light on the conflict between common sense which said these presences were something I was endowing the place with, out of fancy, imagination, and another sense which was intensely aware of the value of the experience and loth to believe it was 'only imagination'; just as when in love one can struggle against knowing that the miraculous quality is something one is oneself creating. But Santayana's statements also suggested that it was a mistake to call an experience 'only' imagination; they suggested that to try to decide which was more 'real', thoughts or things, imagination or perception, was to be caught in a false dichotomy which ignored the true nature of the relation between them. Although I could not yet see clearly how to formulate this relation I could already guess that it might be prejudice that made the knowledge of one's own part in the transfiguration detract from the value of it.

Having reached so far it was now much easier to understand such statements as:

> 'There are some people so indirect and lumbering that they think all real affection must rest on circumstantial evidence. But a finely constituted being is sensitive to its deepest affinities. This is precisely what refinement consists in, that we may feel in things immediate and infinitesimal a sure premonition of things ultimate and important. . . .
> 'There is, indeed, no idol ever identified with the ideal which honest

experience, even without cynicism, will not some day unmask and discredit. Every real object must cease to be what it seemed, and none could ever be what the whole soul desired. Yet what the soul desires is nothing arbitrary. Life is no objectless dream. Everything that satisfies at all, even if partially and for an instant, justifies aspiration and rewards it. . . . The ideal is accordingly significant, perpetual, and as constant as the nature it expresses: but it can never itself exist, nor can its particular embodiments endure.

'Love is accordingly only half an illusion: the lover, but not his love, is deceived. His madness, as Plato taught, is divine: for though it be folly to identify the idol with the god, faith in the god is inwardly justified.

'Whenever this ideality is absent and a lover sees nothing in his mistress but what everyone else may find in her, loving her honestly in her unvarnished and accidental person, there is a friendly and humorous affection, admirable in itself, but no passion or bewitchment of love: she is a member of his group, not a spirit in his pantheon.'

Santayana: 'Love', *op. cit.*, pp. 40–42

If all this were true it certainly threw further light on the nature of such moments as that plunge into the abyss of a painting when the eye was lost in a secret germination and a coloured state of grace. For, I thought, what did it mean if these ideals which are 'significant', perpetual and as constant as the nature which expresses them really are our dreams? What did it mean if these spirits in our pantheon which, temporarily or permanently, find resting places in the outer world of persons or places or things, what did it mean if they are really our dreams, really the inner created pictures of what we love most in the world, pictures of what we hunger for? Did it mean that though it is an illusion when one thinks one has found the exact embodiment of that goodness in the external world, since outer reality is never permanently the same as our dreams, yet such moments are the vital illusions by which we live? Did it mean that they are the actual moments when the forms of imagination do happily grow significant and without which, somewhere in our lives, we should have no drive to seek permanent objectives in the external world, without which we should only be driven by blind instinct and animal appetite? Did it mean that they are moments in which one does not have to decide which is one self and which is the other—moments of illusion, but illusions that are perhaps the essential root of a high morale and vital enthusiasm for living—moments which can perhaps be most often experienced in physical love combined with in-loveness, but also which need not always require bodily contact and physical sexual experience,

but which can be imaginatively experienced in an infinite variety of contacts with the world?

Now I thought I could answer my own doubts about the passing of the transfigurations and see their place in the context of ordinary living. For I read:

> 'The gods sometimes appear, and when they do they bring us a foretaste of that sublime victory of mind over matter which we may never gain in experience but which may constantly be gained in thought. . . . A god is a conceived victory of mind over nature. A visible god is the consciousness of such a victory momentarily attained. The vision soon vanishes, the sense of omnipotence is soon dispelled by recurring conflicts with hostile forces: but the momentary illusion of that realised good has left us with the perennial knowledge of good as an ideal.'
>
> Santayana: 'Pathetic Notions of God', *op. cit.*, p. 55

If this were true then it was surely by those moments that one comes to know what one loves, comes to hammer out over the years the knowledge of what it is worth striving for; and by this comes to achieve a growing integration in one's living. They were surely moments when, by the temporary fusion of dream and external reality, the dream itself becomes endowed with the real qualities of the peg that momentarily carries it; thus each time one's gods descend they themselves become enriched by that very incarnation. Or rather they become enriched as soon as one takes action to bring this transfigured object nearer to oneself. For it seemed likely that it was not simply the descent of one's gods that automatically enriched the dream, it was the action such a vision stimulated that really enriched it. If it was a person who became thus transfigured one sought to bring them closer, perhaps to share one's life with them, if it was the place of one's dreams, to live in it, if a knowledge or skill that one became enamoured of, one sought to find out all about it and so make it one's own. And in so doing the dream itself became changed, it grew through one's own activity.

Incidentally, the phrase 'sublime victory of mind over matter' surely needed some comment; did it not suggest a disparagement of material things, perhaps equally inappropriate with the phrase 'only imagination' only the other way about?

While trying to get these ideas into words there was one image that would not go away. For days my eye had wandered lost over a whole rich countryside and found nothing to rest upon, except one thing: the chance-seen glimpses of clear streams, places where the

pebbly bottom showed through the water and thereby gleamed with qualities that did not show at all in the dry stones on the path. And now I remembered too that other image, from the August diary, how the thought of sand showing through the crisp froth of small waves had stayed in my mind for weeks. In fact there was now no escaping the idea that those diary notes, made blindly on a seaside holiday, had provided in condensed symbolic form the first statements of problems that it was becoming less and less easy to evade; problems to do with how one ever comes to believe in the full reality of the 'other' at all. At the time of making the diary it had never occurred to me what an achievement such a belief is, not the intellectual or philosophical belief, but the working implicit assumption on which one's power to perform any voluntary action depends; so there had been no reason to ask how one achieves it.

There was another aspect of the problem, however. Even if this idea of the necessity of illusion did provide a useful formulation of certain observed facts of living, even if it were true that one did need, at times, not to have to decide which was the other and which was oneself, such a state obviously had its dangers. It might become so alluring that one did not wish to return to the real world of being separate; like the man in the folk tales who, coming home alone at night, chances on the fairies at their revels and joins them and is never seen again; or only returns so many years later that his whole world is changed and nobody knows him.

Later it became clear that one of the free drawings, called 'Rats in the Sacristy' (Fig. 34) illustrated this danger, as well as the opposite one of being a separate person, with all the responsibilities that involves. But I did not understand this yet and meanwhile there was another problem demanding attention, the fact that not only one's gods could take up their abode in shrines in the external world, but also one's devils. This problem was emphasised by a consideration of the painter's instructions on how one should get 'action' into one's drawings from life and also by a study of the meaning of some of the free drawings. For it seemed that, having found at least a way of thinking about the connection between madness and sanity, I could now bring myself to look at these drawings more carefully.

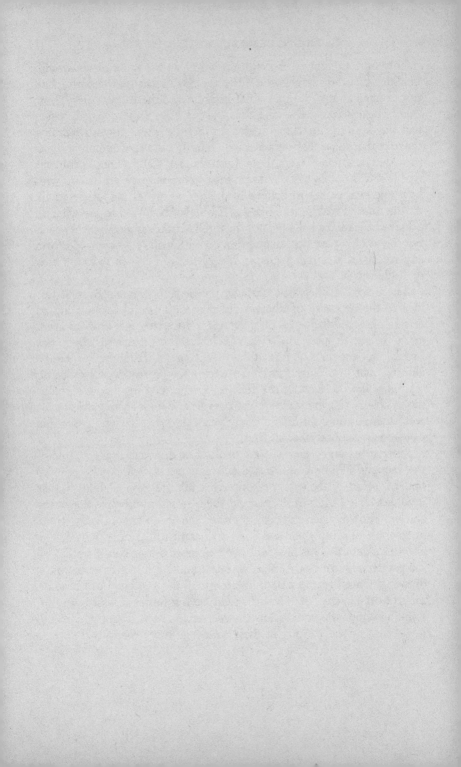

PART II

THE CONTENT OF THE FREE DRAWINGS
(Crucifying the Imagination)

'May all that I can see
Awake, by Night within me be?
 My Childhood knew
No Difference, but all was True,
 As Real all as what I view:
The World its Self was there. 'Twas wondrous strange,
That Heav'n and Earth should so their place exchange.

 Things terrible did awe
 My Soul with Fear:
The Apparitions seem'd as near
As Things could be, and Things they were;
Yet were they all by Fancy in me wrought,
And all their Being founded in a Thought.

 O what a Thing is Thought!
Which seems a Dream: yea seemeth Nought,
 Yet doth the Mind
 Affect as much as what we find
Most near and true! Sure Men are blind,
 And can't the forcible Reality
Of things that Secret are within them see.'
 Thomas Treherne, 1637?–1674

CHAPTER SIX

MONSTERS WITHIN AND WITHOUT

'A Secret self I had enclosed within,
That was not bounded with my Clothes or Skin
. . . .
It did encompass and possess rare Things.'
Thomas Traherne

ONE of the things that had been so dissatisfying about those deliberate drawings which were sheer copying of the object was that they had no life in them. Now I read:

'The true amount of mental sympathy that the student can give to the subject he wants to draw creates a sense of life in the picture. This is very important. From this sense of life the picture begins to have a value of its own, an internal or spiritual value that the artist has added to it, quite separate from its interest as a mere copy of the subject.'
Jan Gordon: *A Step Ladder to Painting*, p. 68

But how did this mental sympathy really come about and what was its nature? Apparently in painters' language it was spoken of as 'action':

'In this sense of what we have called *action* lies much of the true vitality of the drawing. An artist's drawing differs from that of an engineer because the artist's must have a kind of subconscious spirit of life. Much of that strange life in a good drawing comes from the artist's power to seize the action of what he is drawing. . . .

'A mere jug or a basin standing on a piece of paper has in it a definite amount of action. The jug is *standing* on the paper: it is exerting its energy downwards . . . The piece of paper also has action. It is *lying flat*.'
Gordon: *A Step Ladder to Painting*, pp. 64–67

But how did one come to perceive this kind of action in what one saw? How did one in fact give it this spiritual life of its own? One painter's answer was:

'Everyone has two bodies, the real body and the imaginative, whimsical, adventurous, astral self. The real body may go on with its humdrum existence while the astral body is prancing alongside, driving cars at a thousand miles an hour, strangling lions in the Strand.

35

The astral body strolls casually in to lunch at the Savoy while the real body creeps more humbly into Lyons.

'The ordinary man's astral body is of little use, but the artist pulls his in, and sets him to work. At one moment he may have to be a jug, at another a bunch of carrots. When the artist is drawing a living thing, that astral body must become the living thing, it should act as the living thing is acting . . .

'At first you may find this astral body a little rebellious, it would far sooner be an aviator flying the Atlantic than a bunch of carrots: it would rather pose as an unrecognised genius coming into his own than flatten itself out into a field for cows to chew. But by persistent drilling your astral self will come to heel and at last should get tremendously interested in this art job. It must end up as your most enthusiastic help.'

Gordon: *A Step Ladder to Painting*, pp. 206–207

But what was this other adventurous self? Certainly the idea of everyone having an imaginative body as well as a physical one seemed likely to be connected in some way with the transfiguration of the object in the light of one's own dreams. But this thing that one could deliberately spread out, was it really the same stuff as one's dreams? If so, why was it so essentially spatial and yet at the same time infinitely pliable and receptive? Certainly I had repeatedly found, only had been almost unable to believe my own observations, that my whole relationship with other people as well as objects, works of art, nature, music, could depend upon what I did with this imaginative body rather than with my concentrated intellectual mind. And the main thing about this capacity seemed that, although obviously an aspect of the mind, it did feel like a body, in that its essential quality was this sense of extension in space. It always had a more or less spatial shape, even when to do with music, in contrast with the more intellectual capacities of the mind concerned with reasoning and argument, which seemed somehow above or abstracted from existence in space.

Although not fully understanding just what this thing was that could be so spread out I tried deliberately using it by setting myself exercises in seeing 'action' in nature. Surprising things happened. For instance:

' . . . that chair I am looking at, it seemed to be rearing its back, throwing forward its seat, straddling its legs, full of aggressive defiance. And that chest of drawers over there, it's like a great sinister grinning mouth, like Mickey Mouse's piano that danced about and gnashed its teeth.'

But this surely was not the kind of action the painters talked about, it was something much too primitive and childish and vehement, more

like the animism of savages which sees spirits and magical influences in
all the objects of nature.

When looking for an explanation of this experience the thought of
the free drawings forced itself into my mind, together with an urge to
study what they were actually about.

I had, of course, already recognised that they were about feelings or

FIG. 12

moods, that the blasted beeches and heath fire and Noah's Dove
drawings represented states of mind, they were not records of external
facts but of internal ones. But up to now it had seemed that they were
records more concerned with psycho-analysis than with painting. This
was mainly because the majority of them had emerged at a time when I
was undergoing the process of Freudian psycho-analysis myself. I had
undertaken it partly with the intention of gaining added equipment
for scientific work, and it had been during the early period of the
analysis that I had often, in moments of relaxation in the evenings,
settled down to draw by the free method. I had tried not to see any
connection between these drawings and efforts to learn to paint,

because psycho-analysis was part of work and painting was not, and it had seemed preferable to try to keep them separate. Clearly many of the stories of the drawings illustrated recognised aspects of psychoanalytic theory, some of which I had actually discussed in analysis and read about; also the drawings had usually been shown to the analyst. But although I had myself seen psycho-analytic meanings in some of them, from time to time, I had so far never studied the drawings as a whole, either in relation to the special problems of learning to paint, or

FIG. 13

in their relation to the question of how both one's gods and one's devils could take up their shrines in the external world.

With this idea in mind I remembered that there were many of the free drawings in which some sort of monster appeared, and I now sorted these out. The first noticeable thing about them was that there was usually a harmless and innocent creature, as well as a nasty one, and that I myself was identified with the innocent one; as if one might be trying to feel that this was what one's real self was like. Also the harmless creature was usually threatened by some sort of danger from the unpleasant one. For instance, there was a drawing which had emerged once when, after a day of walking in the country and wondering about the difficulties of drawing from nature, I had begun idly

scribbling in charcoal (Fig. 12). The following story had emerged when I looked at the drawing:

> '... the little shadowy animal on the right, a sort of Mickey Mouse, was walking in the summer woods, happy and revelling in the sunshine. Suddenly he sees smoke and greyness coming towards him, blasting the green things, a witch approaches, foul and bent with huge bats flying round her head, stinking things buzzing like blow flies round a corpse. Wherever her feet touch the earth they burn up the grass and flowers, blasting the whole summer day, leaving a trail of grey desolation behind her and a hot blood-red sky.'

There was also Figure 13:

> '... the good obedient little mouse has come out to eat his frugal supper. But in through the window has flown a frightful blood sucking creature, half mosquito, half bat, who is going to steal the mouse's supper—and outside the window there are plenty more like him.'

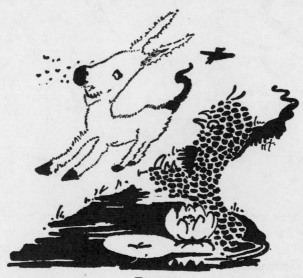

FIG. 14

and Figure 14:

> '... the young donkey, silly and innocent, was happily looking at its own reflection in the water, admiring itself and the beautiful water-lily. But from under the water-lily comes this serpent creature. I remember when painting it that I thought I was painting the ripples in the stream, but they turned out to be this creature. All the same,

I think it is only mock sinister, not nearly as awful as the Blasting Witch, in fact it looks a bit of a fool, more like an angry hen than a devouring monster.'

It was still another drawing of this type (Fig. 15) which gave the first hint as to what might be happening here. This one had no 'story' and although after drawing it I had no ideas about the attacking creatures, the shark and amoeba and kite-like animal, the figures supporting the greedy-looking bottle were clearly cooks or nurses. And here I suddenly became aware of a reversal, for the bottle was demanding from the baby, not the baby from the bottle. This gave the hint that there might be a reversal in all this set of drawings and that the pictures might be illustrating a process which I knew intellectually to

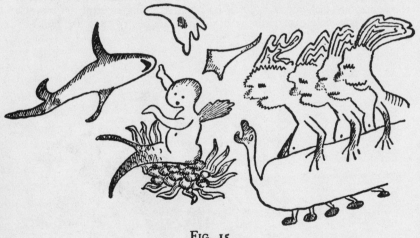

FIG. 15

be characteristic of the blind part of one's mind: the trick of trying to get away from the necessity to admit unpleasant things in oneself by putting them outside and feeling that it is others who are bad, not oneself. So the baby can feel threatened by greedy creatures around him who seem to wait to eat him up when in fact he is the greedy person who wants to do the eating.

There was yet another picture which brought home the truth that the attacking creatures must be really within myself (Fig. 16). It was called 'Freedom':

'The dancing figure comes gaily out of his house on a spring morning thinking he has successfully buried external authority and can now be himself and enjoy himself in his own way. But he meets this monstrous

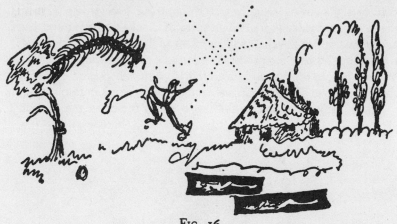

FIG. 16

centipede on the tree just as the Mickey Mouse creature met the Blasting Witch. Surely I have seen this centipede before, yes, it emerged as an image that time I used to seek for peace by concentrating on the source of life within myself, when I used to find it somehow in the centre of my spine—until this centipede appeared.'

This image of the centipede, when it originally appeared, had given me such a shock that I had turned away from it at once, thinking that such an idea must be near madness. But now, having learnt considerably more about how the mind makes use of images, I was able to see what was happening; my mind was trying to tell about the angry attacking impulses that are an essential part of oneself, but the existence of which I had persistently tried to deny. Obviously such an expression of hidden aggressive impulses in an indirect or symbolic way was part of the ABC of psycho-analysis and the analytic implication of the picture was clear enough. Not having been able to admit the angry tearing impulses against the parent figures, in their role of frustrating authority, having striven to believe oneself a 'good' child, the angry feelings are then felt to be coming at one from outside; thus the dancing figure is being threatened by the same tearing biting anger that he originally felt towards those who restricted his will, the same anger which made him want, in imagination, to bury his parents. But the point, for my present purpose, was that here surely was a pictorial dramatisation of that very process that I had consciously observed happening when setting out to try to see 'action' in nature. When consciously observing the chair growing defiant and the piano beginning to gnash its teeth, I had surprised in the act, as it were, a process

that usually goes on secretly and without our knowledge. Granted that it was a particularly childish form of devil that had found itself an external peg in the chair and the chest of drawers, I did not think it altered the fact that the process itself might be something to be taken into account in difficulties in learning to paint. Also even the fact of the childishness of the devils was something to be taken into account.

'Lamb in Wolf's Clothing' (Fig. 17) also indicated the difficulty

FIG. 17

of accepting certain aspects of the self as one's own, it seemed to show the need to pretend that the destructive greed and wolfishness, if it ever did manage to emerge, was something put on as a disguise, not part of one's own inherent nature.

Now I thought I understood better, if there were so many imagined dangers growing from unadmitted angry and greedy feelings, why the imaginative body could often feel contracted to a tight knot inside, like a spider hiding deep in its hole. And no wonder it was difficult to put life or action into one's drawings if the solidity of objects, which included their intrinsic identity and unseen insides, could become the

lurking place of all the dark rebellious feelings within oneself. Once one began this game of endowing external objects with a spiritual life there was no knowing what might not happen, the spiritual life might turn out to be an infernal one. To see life and action in inanimate things was then a trick of the imagination which had better be firmly repressed, else the chairs and tables and jugs might suddenly get up and hit one over the head. So one might become mad, a fear hinted at in the bats flying round the head of the Blasting Witch. And the fact that these forms of life the imagination conjured up were not 'real' in the external sense would only increase the fears, for if I was seeing things that were not there, then certainly I must be mad: and when it was a question of trying to draw, not only objects, but living people, what then? To feel the real separate identity of another person, as compared with an orange or a jug, and express this in terms of paint, must raise even greater difficulties. And when it was not only a question of drawing other people, but the give and take of living with them, did not the same thing apply? To recognise the real spiritual identity of other people in everyday contact, in fact, to use one's imagination about them, might seem equally fraught with dangers, it might seem much safer to mind one's own business. Also one's capacity to allow for the spiritual identity of others in daily life, one's capacity to allow them to be themselves, must be linked up with one's capacity to allow oneself to be oneself. It was all very well to be told to love one's neighbour as oneself, but supposing in fact one did not love oneself at all but hated and feared it? Figure 18 seemed to show another way of attempting to deal with such hatred, not by putting it outwards, but by self-punishment, a sort of cancelling-out process:

'... wasn't it Salome who asked for the head of John the Baptist on a charger? Now the same thing has happened to her as a punishment for murdering the man of God.'

FIG. 18

I now understood more about a certain passage in a book on painting, the implications of which I had been unable to grasp on first reading it:

> 'The condition of vitality next involves the emphasis in each symbol of the living forces, the vital character, of the thing represented, in preference to mere surface qualities. This effect of vitality will be enhanced if the symbol states no more than the essential features, if it states them clearly, and if it states them swiftly, for the very swiftness of the execution will convey a sense of power and liveliness to the spectator. This vitality must also be accompanied with the tenderness and subtlety born of long and earnest insight into nature, or the symbol, though spirited, will be shallow. . . .'
>
> Holmes: *Notes on the Science of Picture-Making*, pp. 304, 305

For now I understand something of the kind of denials in oneself that could prevent that subtle tenderness. In order to experience such a tenderness for nature outside, in all her forms, one had surely to have found some way of coming to terms with nature inside; or rather, with those parts of nature inside that one had repudiated as too unpleasant to be recognised as part of oneself. Otherwise the unadmitted opposites of the frugal mouse and the innocent donkey would be liable to make nature hated instead of loved, the peaceful summer morning could turn into a raging fire or a blasting blizzard.

DISILLUSION AND HATING

'And then I changed my pipings,—
Singing how down the Vale of Menalus
I pursued a maiden and clasp'd a reed:
Gods and men, we are all deluded thus.'
 Shelley

ALTHOUGH it had been impossible to escape from the idea that these monstrous creatures could in some way represent parts of myself, there were still many questions to be asked about them. For instance, where had they really come from? Had I, in fact, felt like that once even if there was no conscious knowledge of it? Or was there being no knowledge of the feelings the very reason for their appearing in this monstrous form? And was I still secretly harbouring such monsters; because they had been denied were they still lurking somewhere, remote and separate and therefore unmodified by common sense and experience? And if so, what was their cause, was it just 'original sin', an inborn inheritance of primitive aggressiveness? Or were they only due to the unnecessary frustration of a too rigidly 'moral' upbringing and restraint of instinctive freedom? I knew some people believed this last theory, they believed that man was born 'good' and that it was only unnecessary frustrating authority that made him 'bad'. In order to investigate such questions I looked at some more of the drawings, and found that many of them certainly did deal with the theme of rebellion against an imposed authority and imagined destruction of it.

There was one drawing, for instance, which showed a blazing castle on a hilltop, with shadowy figures in the foreground (Fig. 19); while making it I had had no idea what the figures were doing but when it was finished the following story had emerged:

'... of course, the horseman on the right is Macbeth, he is watching, bewildered by what he sees, but with a dim possibility in the back of his mind, though he is still the noble servant of his king. On the left are the three witches, hatching the nefarious plot. And the burning

45

castle above, what do castles mean? Castles, law and order, the seat of
government, power and protection, the king—all that is being
destroyed just as Macbeth destroyed Duncan.'

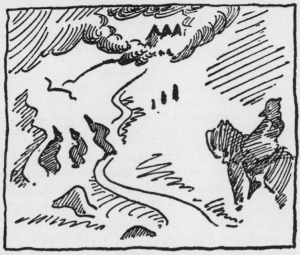

FIG. 19

Further aspects of the problem of rage against authority were shown
in other drawings. For instance, just as the one called 'Freedom'
(Fig. 16) had indicated that one might not only have wanted to attack
and destroy the frustrating authorities but also feel as if one had actually
done so, internally and in imagination, so also in another picture
(Fig. 20) called 'Skeleton under the Sea'. This had begun as a free
water-colour sketch made only with a brush and in different tones of
blue; it had turned into a landscape of jagged ice mountains, in which
the dim shape of an ice demon had frozen sky and earth into an
agonised tension of lifelessness. Actually I had painted over the ice
demon as soon as he appeared, feeling quite unable to face him, and
had then torn up the picture. Later in the day, however, I had begun
another painting in blue which had finally emerged as the Skeleton
under the Sea. After it was finished I recognised it as belonging to a
fairy tale I had once written. In the fairy tale there had been no
explanation why the skeleton was there, the story had only been con-
cerned with attempts to bring it to life. But I thought now that the
torn-up ice-demon picture did throw light on the origin of the skeleton;
for it surely showed ideas of how an alien force from above could

freeze up the flow of life, congealing and fixing the free movement of feeling into a pattern of outwardly correct behaviour and inner lifelessness, as a young rabbit is frozen at the approaching shadow of a hawk.

Incidentally, I noticed here how very wholesale the blind thoughts of the mind could be; they seemed to look on the controlling influence of imposed rules, authority, orderliness, as something utterly fixing, instead of as a support necessary in moderation when the free movement of feeling threatens to become an overwhelming sea. Thus authority appeared as an absolute and deadening tyranny which could only be dealt with by an absolute and complete destruction through committing it to the depths of the ocean. But if this absolute idea of order as something relentlessly imposed from above could be the basis

Fig. 20

of one's unwitting thoughts, no wonder it might be difficult, in painting as well as in life, to combine free expression of mood and feeling with an ordered and well-planned design. If, in imagination, one could destroy the very symbol of order and control within oneself, then no wonder it might at times feel that one had no resource but to copy the ordered behaviour of others, whether in painting or in living.

Another drawing (Frontispiece) called 'The Angry Parrot' showed

not only rebellion against the controlling authorities but also the feeling of urgent need for their protection, even for their help in controlling the anger they themselves aroused:

'. . . the bird is angry and terrified—terrified of the waves that seem likely to engulf it, angry lest the precious egg be taken away. The egg is important, partly because it floats on the sea and so provides a resting place, also the parrot feels it is going to hatch into something very important though it is not sure what. And it is afraid that the Grey Woman is going to take the egg away, also that the black pincer-like thing coming down from the skies is going to attack it, perhaps at the Grey Woman's suggestion.

'The Grey Woman is very powerful, she is not harmed by the waves and can even calm the storm by her presence, for there is a gleam of sunlight on the water near her. She is looking rather pained at the parrot's anger and greedy determination to hang on to its egg, and she has in her hand a bunch of sweet-smelling flowers, which shows she knows where the safety of the land is, whereas the parrot does not. But the flowers are like the bunches carried by judges in the old days to protect them from the smell and disease germs of the prisoners: and for all her mild looks she is there to judge and although she tries to hide those nasty purple spikes down her back they are there just the same. For all her saintly looks I think she is really greedy, or the parrot thinks so, anyway, it thinks she's got designs on the precious egg.

'As for the black thunder cloud shaped like claws, it's probably God and the murky beam to the Grey Lady's head suggests she is the Lord's Anointed—anyway, she is definitely in league with the thunder cloud and could probably persuade the thunder-pincers not to grab the parrot —if she wanted to.

'On the whole I think the parrot is in a difficult position: it needs the protection of the Grey Woman, and will have to please her if it is to get safely through the storm without being drowned: but it thinks she is an old hypocrite and not to be trusted too far. Lord knows what is going to happen to the egg.

'The parrot certainly seems to be me. What then is the way out, how is it going to escape being drowned in those stormy seas of feeling? For if it gives in to what "they" want, the grabbing Thunder-god and the Grey Lady, if it lets them take its precious egg, it feels it will lose its identity altogether and never be a separate person at all. And yet if it does not give in they may destroy it as a punishment or go away altogether and leave it to drown.'

It was clear, of course, from the story of this last drawing, that it referred in part to the psycho-analytic situation, it represented the common fear that being analysed meant having to give up something that one was clinging to. But I felt sure it did not only refer to this, it had a bearing upon the general educational problem as well; for I

suspected that if I only knew what the parrot was so afraid of losing I would also be able to see more of what current educational practice was leaving out.

What then really was this egg that the parrot felt could alone save it from drowning in the stormy seas of its own anger? At first I had thought it was just a symbol of childhood wilfulness, the childish belief in oneself as the centre of the universe and in one's own right to have what one wants and when one wants it. I had thought that the parrot's anger was based on the fact that every child's first love is totally exclusive, its whole world is its mother, and its feelings when it first discovers it has to share her can be very tempestuous. I also thought that the parrot's fear was partly because, being so utterly dependent, a child is therefore terrified of being separated from or earning the displeasure of those it loves so much and needs so much. I thought the picture also showed what happened later when the loved and commanding and feared parents, who formerly controlled the disruptive storms of rage, are no longer standing by, it showed what went on inside oneself, when the parents' demands seemed to come from within, from a judging and demanding conscience. But here came in the angry parrot's dilemma. For to do things or not to do them just because 'they' said one must or must not, or because 'they' would be pleased if one did or angry if one did not, even if 'they' seemed to be inside oneself, this was surely an evasion. It was an evasion of the responsibility of being a separate person who could not, without dishonesty, see permanently eye to eye with anyone else. Of course, such conformity was necessary at times, or social living would be impossible, but it was no solid rock on which to base one's living, for it seemed a bartering of one's birthright of the unique viewpoint. I had often enough found myself behaving according to these inner commands and then been shocked to notice that they were not standards which I myself agreed with at all; I had taken them over wholesale, oblivious of the fact that they were often in direct conflict with my own feelings about what was valuable in life. But although I had often thought over such matters I had not realised, until I looked at the free drawings, how violent the rebellion against these inner authorities might be; and I had not thought at all that such an inner fight might interfere with attempts at creative activity. I had not thought that one's hidden rebellious feelings against order imposed from above could perhaps rush in, like a raging heath fire or blasting storm of cold fury, and fiercely attack the inner commanding authorities, like the fury of a

wild creature defending her cubs. I had not fully realised that the restraint of one's will imposed by authority could at times feel like a threat to one's whole existence, an attempt to separate one from the very source of one's creative relation to the world; and that to give in to this imposed restraint could at times feel like the deepest cowardice and betrayal of one's whole identity.

But this meaning for the egg, as standing for the sense of one's own separate identity, in so far as this is bound up with one's own personal urges towards the world, seemed to be only a partial explanation, true as far as it went perhaps, but not going far enough. In fact I began to suspect that it was not just the over-riding of one's will that was so hard to bear; it was something deeper than that, more to do with the danger of losing one's whole belief in any goodness anywhere, it was this that the parrot was so frightened of and angry about.

I now found two drawings, one made immediately after the other, which showed not only a fury of rage against frustrating authority, but also a process of denying such rage (Figs. 21, 22).

The first had started from a scribbled shaded line that had turned itself into an ape-like creature; but it was not until several days after drawing it that I had noticed its implications and the violence of the emotions implied:

'... the ape creature is terrified of something. I remember that when drawing it I wondered what he was so scared of, it seemed to be something outside the picture in the direction he is looking at. Now I see that he is turning his head away from his own hands, hands which are red with blood and aching to attack the two serpents. The serpents are chatting happily together, it is their garden, Adam and Eve, parents, and they can't be bothered with the ape, in fact they have no idea how awful he feels. The tree is the Tree of Knowledge of Good and Evil, the ape is turning away because he cannot bear to look at them and face the jealousy and rage and fury they arouse: fury partly because he is shut out and doesn't know what they are talking about, like a child whose parents have shut the door in its face, partly because they own the garden and can order him about.'

Immediately after making this drawing and before thinking at all what it might be about, I had turned to a fresh sheet and done another (Fig. 22). The following description of it had emerged:

'... that head with its ears stopped, eyes shut, lips sealed, blind and deaf and dumb, it's surely a picture of defending oneself against something that is too awful to know. Yes, and the wheel-like thing looks like a Grecian helmet, a protection, protecting oneself from knowing.

FIG. 21

I think it's shaped like a wheel because of the way thoughts go round and round in one's head when there is something too painful to face. And why this hairy ear and the duck coming out? Oh, I see, of course, hairy ears like a donkey, escape by not knowing, being a nitwit, fool, donkey. And the duck, surely that's a defence against psycho-analysis, the suggestion that its interpretations are all quackery, I won't listen to them. And the red signal, that's a danger sign, though the fact that it is "down" suggests that there are mixed feelings, the hint of a hope that the situation is not really so dangerous, only an imaginary danger.'

Fig. 22

This second drawing coming immediately after the first did, I thought, confirm my guess about the meaning of the other angry drawing, of the parrot defending its egg. For the Angry Ape and its sequel seemed to be saying that what had to be so urgently defended against was knowing an experience of disillusion, a disillusion that if known about could seem to threaten all one's belief in any goodness anywhere. Certainly there was in the Angry Ape drawing not only a depicted experience of rage against frustrating authority but also a recorded experience of disillusion; for the father and mother serpents are certainly not living up to the ideal expected by the ape child.

Having reached so far, was it not now possible to attempt some answer, in a more general way, to the question about where the monstrous rages came from? Was it not perhaps true to say that the Angry Ape drawing depicted a more or less inescapable aspect of the human situation, an inescapable result of the fact that men are not born knowing the difference between thoughts and things? For if the idea of perception being no primary phase of consciousness was true, then was not the parrot's egg partly a symbol of the necessary illusion of no separateness between subject and object; an illusion which, if shattered too soon and too suddenly, could perhaps be felt as undermining the very foundations of one's hope of eventually achieving a true objectivity?

There was also another drawing which showed, to a less dramatic degree, the attempt to get away from the knowledge of emotions of

FIG. 23

jealousy and hate, in fact, to escape the knowledge of disillusion. It was called 'The Escaping Bear' and its story was (Fig. 23):

'Those three creatures that look like beetles are really eyes, "I's", they are involved in a stream of attraction and repulsion, two are being drawn towards the central figure by the beams of words, feeding on the beams, one is being driven away, both by a stream of words and beams from the eye. The three-faced figure with the paper crown is like the King and Queen and Jack in a pack of cards. The little bear on the right, coloured green, is trying to get away from all this attraction and repulsion of eyes, but finds that it bumps along behind him like a tin can tied to a cat's tail—he's got to "bear" it, whether he likes it or not. "That we may learn to bear the beams of love," Blake said. But of hate, too, beams can burn as well as warm, can blind, destroy the eyes, the "I".'

Of course there were also other aspects of the role of illusion to be considered, not only its role as a bridge leading to objectivity, not only the emotional disaster that could arise if the bridge were broken too soon and the change from innocence to experience not accom-

plished in the child's own time. For instance, there were the advantages of disillusion to be considered. Undoubtedly the dispelling of an illusion is something that works both ways, it can not only be a source of rage and disappointment but also a source of relief; as when one wakes from a nightmare, or finds that one's imaginary fears are imaginary.

There were also further aspects of the need for the controlling force, as well as rage against it to be studied. These were to be forced on my attention when considering the subject of rhythm in painting, together with those qualities of a work of art which are usually spoken of under the name of form as distinct from content. They were to raise the whole problem of one's capacity to believe in any non-willed order, any force working for good that was not part of one's conscious intention and plan; but meanwhile there were more monstrous creatures to be considered, not only angry but also hungry ones.

PRESERVING WHAT ONE LOVES

'O Rose, thou art sick!
The invisible worm
That flies in the night,
In the howling storm,

Has found out thy bed
Of crimson joy,
And his dark secret love
Does thy life destroy.'

William Blake

THE IDEAS associated with the Angry Parrot and Angry Ape had led to the consideration of this one central hypothesis: that there might be some acute and critical moments in the history of one's power to accept, emotionally as well as intellectually, the distinction between subjective and objective, self and other, wish and what happens. And not only could these moments include the remembered disillusions of childhood; for the blind and deaf and dumb head of Figure 22 suggested that there could also be other disillusionments, firmly hidden away and either actively forgotten or perhaps themselves belonging to the time before the remembered years.

But was there no way out? Had one no resources against the bitterness of such moments? These questions brought me back to thinking more about the phenomena of spreading the imaginative body to take the form of what one looked at. For might not this power to spread around objects of the outer world something that was nevertheless part of oneself, might it not be a way of trying to deal with the primary human predicament of disillusion through separation and jealousy and loss of love? For instance, I read:

'In painting one of the prime sources of inspiration is the queer feeling that the subject is "yours". You have enclosed it in your mind, you have absorbed it spiritually and are going to transform it into art. This sense of your spirit enveloping the subject comes naturally and instinctively.'

Jan Gordon: *A Step Ladder to Painting,* p. 125

So also Traherne said:

> 'Cursed and devised proprieties,
> 　　With envy, avarice
> And fraud, those fiends that spoil even Paradise,
> 　　Flew from the splendour of mine eyes,
> And so did hedges, ditches, limits, bounds,
> 　　I dreamed not aught of those,
> But wandered over all men's grounds,
> 　　And found repose.
>
> Proprieties themselves were mine,
> 　　And hedges ornaments;
> Walls, boxes, coffers, and their rich contents
> 　　Did not divide my joys, but all combine.
> Clothes, ribbons, jewels, laces, I esteemed
> 　　My joys by others worn:
> For me they all to wear them seemed
> 　　When I was born.
>
> 　　　·　　　·　　　·　　　·　　　·
>
> 　　Not fetter'd by an Iron Fate
> With vain Affections in my Earthy State
> 　　To anything that might Seduce
> My Sense, or else bereave it of its use
> 　　I was as free
> As if there were nor Sin, nor Miserie.'

But surely it was a way out which did not always work? For Traherne also wrote:

> 'I neither thought the Sun,
> Nor Moon, nor Stars, nor People, *mine*,
> Tho' they did round about me shine;
> And therefore was I quite undone.'

But why did it not always work? Was it because, although by such spiritual enveloping of what one saw one did make it, in imagination, part of oneself, this was in fact an illusion, the things one saw were not really one's own, one's self was still really bounded with one's skin; 'hedges, ditches, limits, bounds' still existed, although temporarily transcended. Thus however fruitful such illusion might be in enriching the imaginative life, however necessary it might be as a stage in coming to believe in the reality of the real world, it did contain a denial. It contained a denial of the basic fact of one's bodily life which does not transcend space, and is totally dependent upon the transferring of matter (eating) from outside to inside and from inside to outside (excreting) for its continued existence.

I had already felt that there could be an imaginative connection between this spiritual enveloping of what one loved and eating, for I found an old diary note on this theme:

'... the impulse to paint those flowers, crimson cyclamen, feels like a desire to perpetuate the momentary glimpse of timeless peace that is given by the extension of their petals in space. I want to taste it continually, swallow it, become merged with it—just like those feelings of wanting to eat a landscape, or even having eaten it; as if there was an equal expanse of space inside one, a sort of through-the-looking-glass land. And like when having drawn an animal at the zoo—eagle, panther, horned beast—with his still vitality, after drawing them I feel that I now possess these lovely vital things—rather like the childhood pleasure of having an animal as a pet.

<div style="text-align:center">

Golden lads and girls all must
Like chimney sweepers
Come to dust.

</div>

That's partly why I want to paint, in order to preserve.'

But if there was this connection with eating might it not explain why the inspiration of spiritual enveloping often failed as soon as one began to draw? Before beginning one could spiritually envelop the object and feel inspired, transcending space and separateness. But once begun it was necessary to face the fact of being a body that does not transcend space as the spirit can. At the moment of having to realise the limits of the body, when beginning to make marks on the paper, all the anxieties about separation and losing what one loved could come flooding in. And then there could come also, with the anxieties, an attempt to ease them by calling on the imposed moral law, turning to rules for the control of the Angry Ape; yet by that very reliance on rules perhaps stultifying from the start the very thing one was seeking to achieve.

Thus it seemed possible that inspiration of the enveloping kind might fail partly on account of its connection with eating and also on account of the inherent nature of eating. For though eating may satisfy the desire to have the good thing in one's own possession, it certainly does not preserve that thing's essential identity and nature, it rather destroys this identity in order to merge it with one's own. This was also perhaps why the idea of spiritual enveloping had roused slight misgivings; it had suggested that subtle secret possessiveness which, under the guise of loving consideration, can hardly allow the other to be itself at all.

Now I saw that amongst the free drawings there were in fact several which showed this theme of eating or engulfing.

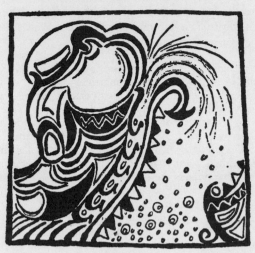

FIG. 24

Fig. 24. 'I think this is really the Small Porgies creature from Kipling's story, who came up out of the sea and ate at one gulp all the food that King Solomon had collected to feed all the animals in the world—only here the things he is swallowing look like seeds and he has got no eyes or features, only teeth and those hair-like feelers which seem to be guiding the prey into his mouth.'

Fig. 25.

'Here again are teeth, they are flame-coloured and about to close on the black ball in the middle. The little red tadpole creature on the right has his hair standing on end in fear and astonishment at witnessing such a relationship. The bird up above was at first going to be the great black crow that frightened Tweedledum and Tweedledee into giving up their battle, but it seems to have dwindled a bit.'

In both these drawings there were teeth, so that the idea of enveloping an object spiritually in order to preserve it, which sounded a kind and loving thing to do, might not seem so if the idea of biting it up was also involved. The cannibal may be prompted to eat his enemy by love for his courage and strength and the wish to preserve these, but it is a love which certainly does not preserve the loved enemy in his original form.

There was another drawing which seemed to depict in quite direct terms the results of such imagined cannibalism, for the drawing itself showed no whole people, only bits of them. It called itself 'Drawing without a Mame' (Fig. 26). I found the picture slightly horrible, as I

Fig. 25

had also found most surrealist paintings, a feeling which seemed mainly due to the impression such pictures gave of separate unregulated 'lives', the dominance of the accidental and lack of obedience to any laws, like the aimless malevolence of poltergeist phenomena described in books on psychic research. And the first thing I noticed about this drawing was the mouth theme, both in the two red-lipped faces and also in the apparently mouthless mannikin emerging from the eye in the main face; although in fact he has a mouth, but it is represented by the little black blob outside the circle of his face. In fact this last detail suggested that one might wish to push away the thought of the mouth as something too destructive, and pretend that it did not belong to oneself at all. And the eating theme was repeated in the jelly-fish shape on the left, the jelly-fish being a spineless creature that is almost nothing but an enveloping mouth; while the dots below it suggested the breaking into bits that is the result of eating, as did also the rows of dots in the body of the mannikin, though both these sets of dots also seemed to represent spores or seeds. The tufted caterpillar entering the ear also repeated the eating theme, since a caterpillar is always eating, continually making a trail of great holes in leaves, even causing sometimes, I believed, the death of an oak tree by its voraciousness. A reference to the fact that the first contact with the 'other' is with the mother's breast

seemed to be given by the round breast-like shape on the left; but this is shown surrounded by a shape which my first thought said was the handle of a crutch, as if the breast might have become injured by all these biting mouths. And here I remembered Blake's words:

> 'The caterpillar on the leaf
> Repeats to thee thy mother's grief',

a remark which had always before seemed quite meaningless; but now I thought it expressed the fear that one's babyhood greedy kind of

FIG. 26

loving could have injured the life-giving breast. The row of spikes on the back of the main head also introduced the idea of teeth, though the fear of possible results of biting had apparently led to the teeth being put well out of sight at the back. Here I remembered also the spikes on the back of the Grey Woman in the Angry Parrot drawing. As for the dunce-like eye-less head emerging from the main one, there was (as in Figure 22) the implication that all these meanings must not be

seen or known, it was safer to remain ignorant. Finally a connection with the visual arts was implied in the fact that the mannikin whose possession of a mouth is denied actually grows out of the eye, thus suggesting that looking intently at an object, devouring it with one's eyes, can seem also a potentially destructive act. Needless to say, no notion of such meanings as these was in my conscious thought when drawing this picture, I had merely been experimenting with a new box of chalks and amusing myself with whatever shapes my hand seemed inclined to produce. It was only the insistent way in which the drawing kept coming back into my mind which drove me to find meaning in it, as if it were a ghost persisting in walking until what it had to say was attended to.

Here then was another fact of babyhood experience to be taken into account, the fact that a baby's first impulses towards the outer world are shown in the attempts to put everything in its mouth. And if one's first attempts to relate oneself to the outer world are mainly in terms of eating, chewing up, swallowing, must not this fact leave its mark upon one's subsequent attempts at relationship, especially the relationship of painting from nature; that is, if painting is to be a true

FIG. 27

exploring of the depths of feeling, not just a recording of matter-of-fact and detached seeing?

Further aspects of this same theme were also hinted at in a drawing of a human figure which turned into something I had not expected. I had intended to draw from memory an outdoor café scene and had begun with the waiter; but after he was drawn it occurred to me that he was not really a waiter but a butcher. What is more, he insisted on being given the title of 'The Pregnant Butcher' (Fig. 27). And when looking at this sketch I remembered how, in the 'Drawing without a Name' the bits in the body of the mouthless mannikin and the bits falling from the jelly-fish shape, were also seeds; thus the idea of the butcher being pregnant was surely expressing the idea of giving the object new life as an artistic creation, in fact, the idea of the artist as creator. But this thought brought back my original anxieties, for the butcher, although he might be pregnant, was none the less a butcher. I could not still the doubt that what he created might be bad, since it grew out of an initial destructive act. And there were also other drawings suggesting the potentially sinister aspect of creation: for instance, 'The Farmer's Wife' (Fig. 28), an unpleasant creature who

FIG. 28

puts the tails of mice into her cauldron. Also this cauldron was associated with those witches in the Macbeth drawing who brewed evil from their pot, and again suggested the doubt whether what was produced from the initial destructive act of cannibalistic incorporation might not be also destructive and evil in itself.

This last idea seemed possibly to explain the quite unreasonable fears that a painting would be 'no good', fears which could so often make it impossible even to begin. I say unreasonable because reason said what did it matter if it was not a good picture. If it were bad it could be torn up, it was absurd to feel it so much a matter of life or death whether the picture was good or not. But evidently in one part of the mind they were felt to be life-and-death issues, and this was clear from the associations to another picture (Fig. 29). It was called 'Queen Elizabeth and the Bashful Parrot', and the thought that emerged after drawing it was a half-remembered verse, by Kipling, about Queen Elizabeth looking in her mirror:

'Queen Bess was in her chamber, and she was middling old,
Her petticoat was satin, and her stomacher was gold.
. . . .
Singing, backwards and forwards and sideways may you pass
. . . .
But you'll never see a queen as wicked as you was.'

The crosses in the background stood for graves and I realised as I looked at her that Queen Elizabeth herself was also Hecate, Queen of the Dead. No wonder then that the parrot was bashful and afraid to take the risk of bringing out what it had taken inside, if it could so feel that the inside world might be a world of the dead. The scribble at the top of the page is the first version of the drawing. I had been dissatisfied with it as meaningless bits and had nearly given up the effort to draw altogether.

It seemed then that one could attempt to avoid the sorrow of change and separation and loss by spiritually enveloping what one loved and taking it inside oneself, but that this did not really solve the problem; for there was still the fear that by having it inside, one might have destroyed it. To an established painter, who knows that he can successfully bring what he has taken inside himself back to life in the outside world as a painting, there may be less anxiety in this act of spiritual envelopment in order to paint; but for those of us who have no such knowledge it might seem much safer to make the spirit firmly keep itself to itself and not venture out on any enveloping expeditions.

FIG. 29

There was one drawing, made later than those so far shown, but it seemed to be a sequel to these so may be appropriately considered here. It was called 'The Mount of Olives' (Fig. 30), and its story was:

'... the bones sticking up out of the sand make me think of "The Skeleton under the Sea", the blasted olive tree on the left is a little like the blasted beeches, and also brings to mind the storm in King Lear. And the top of this stunted tree reminds me of the frightened little tadpole creature who was witnessing some primitive devouring process (Fig. 25). The shadowy path in the centre seems to stop at the bones, as if the path forward were blocked by the skeleton.'

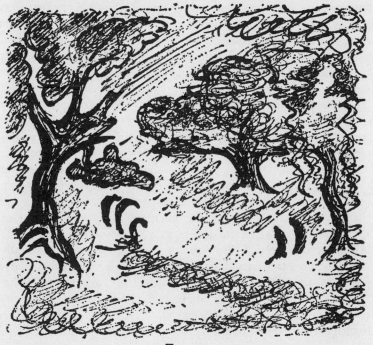

FIG. 30

I did not understand its significance at all, especially the idea of the skeleton blocking the path ahead, until after thinking for a long time about the meaning of the earlier drawings. In fact I did not see what it was about until I saw the aspect of the earlier ones which was to do with the magical fulfilment of a wish. For then it became clear that the Mount of Olives drawing showed the sequel, in feeling, to the magic-ally fulfilled destructive wishes of some of the earlier drawings. Thus,

by its reference to the horror-struck tadpole of the flaming mouth picture it hinted at an emerging horror at what had been done in thought and wish; both in the primitive devouring relationship and in the storms of rage at frustration, storms linked with the thought of King Lear's raging when the doors were shut against him. It showed how the flaming mouth-like thing could stand for the primitive ruthlessness of a love which in the beginning cannot help but destroy in imagination what it loves. Thus I could now see further into the implications of the idea that behind the comparatively sophisticated destructiveness of jealousy and rebellion against authority is a more primitive kind. It is a kind that is inherent in the double fact that what one loves most, because one needs it most, is necessarily separate from oneself; and yet the primitive urge of loving is to make what one loves part of oneself. So that in loving it one has, in one's primitive wish, destroyed it as something separate and outside and having an identity of its own.

Thus there appeared to be a further reason for fear of spreading the imaginative body and plunging into experiences where the boundaries of personal identity were transcended. Not only could such experiences mean giving infernal life outside to denied wishes and impulses of one's own; they could also mean embracing a pain and suffering which one had one's self been the cause of. And when what was suffering was also what one loved most the guilt and remorse could perhaps be very nearly intolerable, one could easily fear being overwhelmed and drowned in the pain of it.

All this also suggested a reason for the presence of the Thunder Cloud God in the Angry Parrot picture. Undoubtedly he in part represented actual lived-through experiences of a frightening father, in league with the mother, as a commanding and punishing authority. But the Mount of Olives picture also suggested that despair about the potential destructiveness of one's primitive love, and its attendant hate, could drive one to set up a terrifying God within, almost as a second line of defence. It seemed almost as if one could seek to provide for a control through fear, in case the power of one's concern for what one loved was not strong enough alone to control the destructiveness.

Such a formulation as this surely also could clarify one's basic assumptions about education. I had lived through the years when it was common to hear certain groups of people talk about 'good' and 'bad' as if they were categories imposed by a repressive regime of child rearing; as though it were a fact that if parents never called their

children naughty, children would never feel naughty, never suffer guilt feelings. But now it was surely clear, to me at least, that one needed no imposed moral code to teach one that it was bad to spoil what one loved, good to preserve and keep it safe. Thus it did certainly seem that there is an inherent as well as an implanted morality. It did certainly seem that one struggles to control greediness and aggression in oneself, not only through fear of being punished or losing other people's love and respect, but also to avoid injuring or even destroying whatever seems to oneself to be beautiful and lovable and necessary. Thus one feels guilty, not only because one has been made to, but also because one knows only too well that there are real grounds for it; in the psychic reality of feeling and wish one has failed, one has certainly, some time or other, been callous and greedy and resentful and destructive. So in one's inner world, perhaps locked up and hidden far away beyond one's knowing, there do exist loved people who have been hurt or even made into dead skeletons by one's angry wishes.

If all this were true then one of the functions of painting was surely the restoring and re-creating externally what one had loved and internally hurt or destroyed. At least, this certainly seemed to be one of the underlying themes of the drawings so far considered. And I realised now that this was also part of current psycho-analytic theory on the subject,* although I had not thought that I had had any intellectual grasp of the theory when I first began making free drawings. But there was that other aspect of the function of painting to be considered, the even more primitive one which the series of drawings on the theme of 'Earth' had introduced. For these had led me to suspect that painting goes deeper in its roots than restoring to immortal life one's lost loves, it goes right back to the stage before one had found a love to lose.

It was this aspect of the function of art that became clearer when I considered the method of the free drawings and the role of this method in realising, or making real, the external world. In fact, I came to see their role, as also the role of the psycho-analyst, as facilitating the acceptance of both illusion and disillusion, and thus making possible a richer relation to the real world.

It was now possible also to see more clearly the relation of this study to earlier ones. In two earlier experiments I had especially studied moments of happiness and significance. In this one, by trying to study

* Theories worked out largely by Melanie Klein, on the basis of Freud's discoveries (such as those described, for instance, in his paper on 'Mourning and Melancholia') and through her own work with children.

difficulties and failures of significance, I was coming to see that certain inescapable facts of the human predicament had not been sufficiently taken into account in the earlier studies. They were certainly facts to do partly with the primitive hating that results from the inescapable discrepancy between subjective and objective, between the unlimited possibilities of one's dreams and what the real world actually offers us; and also to do with the special way in which 'the lunatic, the lover and the poet' (or painter) try to transcend this hate and either succeed or fail. But they were also facts to do with the way in which our whole traditional educational procedure tends to perpetuate this hate, by concentrating so much on only one half of our relation to the world, the part of it to do with intellectual knowing, the part in which subject and object have perforce to be kept separate.

It was now necessary to study the particular method by which the free drawings had been produced. It was largely through this that I came to have some idea of the creative way out from the primary human predicament, a way out that gave due recognition both to the need for separation and no-separation.

PART III

THE METHOD OF THE FREE DRAWINGS
(Incarnating the Imagination)

' . . . the most significant thing in recent thinking is, I think, the corresponding of thought in different fields and on different levels. Philosophy has long taught us the unity of experience. You can tear it to pieces if you will and find subject and object, stimulus and response, or—you can refuse to: you can claim the right to see it as a rational interplay of forces, as the functioning of a self-creating coherence.'

<div align="right">M. P. Follett, Creative Experience, p. 74</div>

RECIPROCITY AND ORDERED FREEDOM

'... as we perform a certain activity our thought towards it changes and that changes our activity.'

Follett, p. 62

'... no human relation should serve an anticipatory purpose. Every relation should be a freeing relation with the "purpose" evolving.'

Follett, p. 83

THE FIRST and most obvious thing about the free drawings was that they were not according to plan. The idea of the limitations of planning, of consciously willed effort towards a foreseen end, was not of course a new idea to me intellectually. But it was quite another matter to try to act upon the idea and then find oneself up against the full strength of one's inability to believe in any non-planned, non-willed order, as I was nearly every time I set out to do a free drawing. So often I found it necessary to mobilise every bit of will-power I could find in order to stop trying to use will-power to dictate the result. But when I did succeed in this I had the fact staring me in the face that the free drawings were so much more ordered wholes than those I had made by conscious effort to produce wholes.

The next task was therefore to try to find out something about the conditions under which the spontaneous ordering forces could express themselves.

First amongst the things to be noticed here was the fact that the mood or state of concentration in which the most expressive drawings appeared had a special quality. It was a mood which could be described as one of reciprocity; for although it was certainly a dreamy state of mind it was not a dreaminess that shuts itself off from the outside world or shuts out action. It was more a dreaminess that was the result of restraining conscious intention, or rather, a quick willingness to have it and then forgo it. Quite often there was some conscious intention of what to draw, at the beginning, but the point was that one had to be willing to give up this first idea as soon as the lines drawn suggested

71

something else. And will did come into it to the extent of the deter-
mination to go on drawing, to keep one's hand moving on the paper
and one's eye watching with a peculiar kind of responsive alertness
the shapes that it was producing. In fact it was almost like playing a
game of psycho-analyst and patient with oneself, one's hand 'talked' at
random, the watching part of one's mind made running comments on
what was being produced. (Cf. Fig. 1.) I found an attempt to describe
the process in diary notes:

> '... in the meaningless scribble type of drawing the line fails to
> answer back and suggest the idea of an object or pattern; thought and
> line, thought and "other", are quite out of contact. When this happens
> I often want to take refuge in the "trying-to-draw-something" method,
> in which one thinks of something, for instance a donkey, and tries to
> make the lines go right, not letting them have their say at all and
> allowing no interplay, like a person who monopolises the conversation.
> This I find produces an infinitely dull drawing, whether I try to draw
> the object as I remember it goes or try to impose motifs or stylisation.
> But there is something in between drawing random lines with all
> thought shut away, and trying consciously to make the lines follow a
> mental image. This is to draw a little, at random, spots, shadings or
> lines, then feel what these suggest and let the line go on, holding both
> it and the idea it suggests in mind, as it were organically with a whole
> body awareness, not trying to develop any thought line by line but
> letting the hand go where it will and letting the line call forth an answer
> from the thought. Often this interplay fails, as in the Ape in the
> Garden, where the ape grew from an interplay, but the trees on the
> right are definitely imposed, I had the idea that I would like some trees
> there and tried to remember how trees would look, but there was no
> reciprocal influence of the line back on the thought.'

Fig. 31 (a) and Fig. 31 (b) illustrated the difference between these
two ways of drawing. Fig. 31 (a) shows a deliberate effort to draw

FIG. 31 (a)

from imagination, it was all I could do after weeks of determination to draw something 'out of my head'; while drawing it I had said to myself 'Here I will put a tree, here a dog, a dog surely looks like this, I wonder if that's right, how does a man look when walking, etc., etc.' And the result was that the lines were like the stilted gestures of a self-conscious person who moves according to the *idea* of how he ought to behave, rather than by his direct feeling response to the situation. Fig. 31 (*b*), on the other hand, had been made without any pre-conceived intention, it emerged solely from interest in the movement of the line made by my hand on the paper.

FIG. 31 (*b*)

The main thing about this mood of reciprocity seemed to be that it was an interplay of differences that remained in contact; though it was often tempting to give up the contact, give up the effort of moving one's hand with the pencil and relapse into simple day-dreaming. The particular pair of differences that was in contact was ideas and action, thinking and making something happen by the movement of one's body, an inner image and the record of a movement represented by the line actually outside on the paper. And it was when these two inter-played, each taking the lead in turn in a quick interchange or dialogue relation, that the drawings had appeared and had embodied in such a concentrated form a whole set of ideas that I had never known I had.

In one sense such drawings could be certainly looked upon as a kind of waking dream; for the study of the dreams of sleep shows what a richness of meaning can be concentrated in a few visual images. But they were certainly not like the usual waking dreams that one calls day-dreams, most of them were much more than wish-fulfilling fancies of what one might hope would happen; they seemed to be, some of

them at least, very complicated reflections upon the central problems of being alive. The difference seemed to lie in the relation to action. In day-dreaming there is no action, thought is just playing with itself, but in the free drawings there was mind and body meeting in expressive action. And it was apparently just this that seemed to be the fertilising factor.

But if the meaningful drawings were the result of such a fertilising interplay, what happened when the drawing that emerged was nothing but an unrecognisable scribble? I did not by any means know the answer as yet. It seemed possible however that there was no recognisable communication in the scribble drawings because some set of ideas and feelings seeking expression had not yet been sufficiently worked over internally, not enough internal work had been done. Of course it might also be that some internal forbidding, based on fear of instinctive forces within, had succeeded in isolating the particular area of feeling and idea stirring at the moment, with the result that it could not become fused with recognisable images and socially meaningful symbols, but would remain private and incommunicable. Or possibly it had so fused with images but they were too instinctively direct and primitive to be acceptable to the conscious self; thus the scribbled line would get no answer from the thought, since thought was in the state of Fig. 22, by self-imposed edict it was blind and deaf and dumb. So what should have been dialogue would degenerate into an extreme monologue of action out of touch with thought, a meaningless babble of lines; just as, to a less extent, the 'imposed' kind of drawing represented a monologue of thinking that would not listen to what action had to say. But there was another possibility. The meaningful drawings might certainly be looked upon as the expression of a tendency of nature inside one to form wholes, a formative pattern-making tendency. But if patterns were not to become fixed, if they were to grow, there must obviously be an opposite tendency, one that would break down old patterns in order that new might come. And surely I had found that too, beginning with the first drawings of the heath fire and the blasted beeches. 'Without contraries there is no progression', said Blake. So here, perhaps, was another reason why chaotic scribbles sometimes appeared. For it might well be, although I suspected other interfering factors at work as well, that one might happen to draw at a moment when the disruptive forces were for the time being in ascendance, and even necessarily so.

In this connection there was one drawing (Fig. 32) which was

hardly more than scribble and yet at the time it had seemed important to keep it. When looked at now it appeared to be a desperate attempt to impose a rhythm and coherent pattern on a chaos of feeling, a need that had apparently been so great that it had broken through the graphic medium and found expressive form in words used as part of the picture. I thought now that it expressed the idea that even chaos, once it has been given a name, is less chaotic. And this reminded me how, when going to a much-discussed Picasso exhibition and arriving 'all-to-bits' from the struggle of living, I had been lifted right out of it by the pictures. And this had seemed because here was someone with

FIG. 32

the courage to recognise and admit such inner chaos; whatever his position as an artist, he at least showed how deceptive the external wholeness of bodies can be, how one can look to the outside world like a whole person and yet be all in bits inside, full of conflicting wishes and chaotic standards, one's self can be nothing but a caddis-worm shell of bits and pieces, picked up anywhere and stuck on anyhow. And he had managed to show this with a kindness and humour, at least in some of the pictures, which made it a much less intolerable fact to face.

One thing I noticed about certain of my free drawings was that they were somehow bogus and demanded to be torn up as soon as made. They were the kind in which a scribble turned into a recognisable object too soon, as it were; the lines drawn would suggest some object and at once I would develop them to make it look like that object.

It seemed almost as if, at these moments, one could not bear the chaos and uncertainty about what was emerging long enough, as if one had to turn the scribble into some recognisable whole when in fact the thought or mood seeking expression had not yet reached that stage. And the result was a sense of false certainty, a compulsive and deceptive sanity, a tyrannical victory of the common sense view which always sees objects as objects, but at the cost of something else that was seeking recognition, something more to do with imaginative than with common sense reality. And here I noticed also how powerful was the intellectual process of recognising a certain shape as depicting a given object; how the naming it to oneself as a potato or a jug or a human face could completely shatter one's awareness of the rhythmic relations in the scribble. Or rather, as soon as a scribble became recognisable objects the whole rhythmic pattern of it could become violently altered and pushed in another direction.

Certainly the ability to believe in an ordered result arising from the free coming together of the two differences, thought and action, did seem to depend partly on a willingness to accept chaos as a temporary stage. But later it was to become clear that this belief and this willingness were no simple matter. There was a drawing, for instance, called 'If the Sun and Moon should doubt, they'd immediately go out' (Fig. 41) which I did not as yet understand at all fully. But it included in its story a reference to the Castle of Giant Despair and certainly had to do with a possible despair about preserving anything good to believe in. For the moment, however, I was more concerned with discovering the exact nature of the creative interplay than with the forces preventing one from believing in it.

REFUSAL OF RECIPROCITY

'Integration, the most suggestive word of contemporary psychology, is, I believe, the active principle of human intercourse scientifically lived. When differing interests meet, they need not *oppose*, but only *confront* each other.'

Follett, p. 156

'Our "opponents" are our co-creators, for they have something to give which we have not.'

Follett, p. 174

THIS DISCOVERY about the method of the free drawings, that they had emerged from a particular kind of dialogic interplay between the two differences of 'having ideas' and 'making a mark on paper', led to a further observation. I noticed that in many of the drawings various sorts of antitheses were shown. Not only were there both malevolent and innocent creatures, there were also other kinds of either-or distinctions such as body and mind, spirit and flesh, things above and things below, standing apart and merging, reason and feeling. For instance, N.B.G. (Fig. 33) was to do with 'things above' and 'things below'.

'The naked female figure is trying to seduce the surprised-looking duck into plunging over the precipice into a great crevasse of earth, it seems to be the Grand Canyon of America, they told us when we went there that if you fall into the Colorado River you are pulled under and drowned by the sheer weight of sand that swirls in the water.
'The skeleton figure on the right is saying "No, you must not do that, you must set your heart on things above." But he has got no body and only a plum pudding head instead of brains. He is offering "pie in the sky" but the figure on the coffin under the crucifix is saying, "It's pretty miserable crucifying the flesh", and the satyr on the left is saying "Come along with me and dance." '

There was another drawing called 'Rats in the Sacristy' (Fig. 34).

'Just above the red ball is that shadowy greenish-blue creature with red eyes, it is a young dragon and it is shying off in terror of the red ball and obviously trying to leap out of its way. In its terror it seems

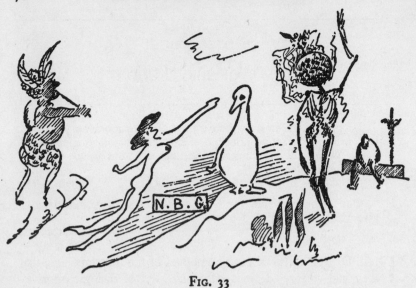

FIG. 33

quite oblivious of the fact that a huge grass-green slug-like sucking creature has got hold of its tail and is trying to swallow it up. Above the green sucker are two shadowy grey things which call themselves rats and are ready to eat up anything that may be left over from the struggle, their eyes are red. The red ball is like the sun, it is just itself, an irreducible entity, it makes me think of Woizikovsky in that Tchaikovsky ballet where he comes leaping in as Fate and separates the two lovers. The wraith-like young dragon, having red eyes, has an affinity with the red ball but dare not face it, and because of this is in great danger from the green slug, although it does not know it.'

In one aspect this drawing introduced the same idea as the Angry Ape. Thus the association of the red ball with the figure of Fate, who in the ballet had been dressed as the devil, seemed another way of referring to the Angry Ape and his raging desire to interfere with the chatting serpents. And since the red ball seemed also to stand for the irreducible 'I', eye, individual viewpoint, the essence of being a separate person, it looked as if the Ape picture had been describing, amongst other things, an actual experience of dawning self-consciousness.

Thus it seemed that the first taste of fruit from the tree of knowledge of good and evil in oneself might come at a moment when it necessarily tasted bitter; when being temporarily not wanted by one's father or mother could indeed seem like the loss of all heaven and earth and all

belief in any goodness anywhere. And this certainly would explain the title 'Rats in the Sacristy', for it was the name given to a book of essays I had once read,* dealing, as I vaguely remembered it, with the sceptical philosophers of history, philosophers who doubted the existence of any goodness of purpose in the universe.

But there was another aspect of the Rats in the Sacristy drawing which linked it to the N.B.G. picture and the splitting of problems into extreme either-or issues. For the predicament of the young dragon, shying off in terror from the irreducible separateness of the red ball, yet at the same time in danger of being swallowed up by

FIG. 34

the green sucker-slug, brought in another antithesis: on the one hand, trying to live as a completely separate person, as the red ball irreducibly itself, on the other, seeking for total merging and loss of all separate identity, such as in the feeling of complete at-one-ness with nature. And this theme of total submergence in nature also suggested that the rats must stand for those gnawing doubts which could so often break in upon the peace of wholeness with nature. It was as if, in the moments in which one did not have to feel oneself a separate person, the shut out individual will might begin gnawing at the foundations of the mystical union with the other. And even the colours carried

* Ll. Powys.

out the same theme. Thus the sucker-slug was grass green because in one aspect it did stand for this being swallowed up in and, therefore, one with nature. On the other hand red, in all these pictures, stood for relationship, aspects of love and hate in contrast with undifferentiated wholeness.

The rats picture was reversible. When looked at the other way up it showed the peace of a summer buttercup field, like that peace of wholeness with nature which had in fact inspired the drawing that turned itself into a heath fire. But across the sky there spreads a fearful

FIG. 35

drama of attack, as if to show the struggle going on in the inner world of feeling. 'That which is above is within.' So the drawing also seemed to illustrate the extreme antithesis or attempted separation of inside and outside. Incidentally, I was here reminded of the great difficulty I had had when making a landscape sketch in seeing the sky as part of the composition of the whole picture, I had always tended to treat it as something separate.

There was another drawing (Fig. 35) which appeared to be dealing with the same idea as the separateness and invulnerability of the red ball, but depicting it as stony in its separateness, and also linking this stoniness with logic and reason which stands apart from feeling. It was not a free drawing but a landscape sketch from nature, made long

before I had any notion of the power to let hand and eye draw freely; at the time it had seemed to be just a simple copy of what was there, a quarry with some sort of machinery for breaking up stones. The drawing had been vaguely unsatisfying, but I had had no idea why. Then, ten years later I had happened to show it to someone who remarked on the curious difference of style between the drawing of the cliff on the left and the buildings and machinery of the main part of the sketch. Not having noticed this before and feeling some disquiet when it was mentioned, I had decided to write down whatever ideas the theme of the drawing suggested.

'. . . that yellow cliff on the left with its curious lines like hieroglyphic writing, it makes me think of Cleopatra's needle, also of the Sphinx, it is half like a person with a kind of crown and tufts of hair and a sharp spiky face. And just below the head, in the bulge of the cliff, is a shape like a heart, like the flint heart in that fairy tale which gave whoever found it omnipotent powers. And the quarryman below looks as if he were doing obeisance to it. A title for the picture keeps coming into my head;

"The Mills of God grind slowly
but they grind exceeding small."

I think the yellow cliff has got to be ground to powder like the golden calf of the Israelites.'

'. . . Cleopatra's needle, believing in the omnipotent magical command, how constantly people try to use it, in newspapers, sermons, everywhere, they say we *must* do this, that, as if that was enough. And it is made of stone, invulnerable, it stands apart and commands and does not spread itself and give of its own substance. In my mind it is close to the tables of stone of the Mosaic law, but also to the law of reason which stands apart from feelings. I remember that in the evening of the day I drew it we sat on rocks by the sea when the sun was going down and I asked H. something about mathematics, I forget what, and he began drawing graphs on a flat piece of stone to illustrate his answer. And always afterwards I have thought of that stone as the shape of a tombstone, with the ten commandments upon it. Now I feel that all these, the Cleopatra's needle, the stone of the imposed moral law, and the imposed logic of reason, they are all in various ways, for me, the opposite of this other kind of control, which comes when the mind does not stand apart from the "other" and apart from feeling.'

Certainly these associations, combined with the title, suggested the fear that if one let go the stony insistence on individual will and identity one would be ground to powder and lose that identity for ever. So here again was the antithesis of extreme separateness as

against total loss of identity. There was certainly fear, but there was also hope, for the idea of grinding to powder led on to the further thought of the healing quality of the drink made from the ground-up golden calf of the Israelites. Also I thought of the crucifix that had appeared in the corner of the N.B.G. picture and of how the enforced out-spreading of the arms of the crucified figure was linked symbolically with the voluntary outspreading of the imaginative body. Thus the crucifix could stand for the fear that spreading the imaginative body to take upon itself the form and identity of the other meant the bearing of intolerable pain, being vulnerable to the pain of the whole world, embracing and taking upon oneself the hurt and suffering thing instead of passing by on the other side. And the theme, again in the N.B.G. drawing, of drowning in the thick waters of the Colorado, also went back to that other fear which I had first guessed at when studying the plunge into colour; fear of the plunge into no separateness from the other when in fact that other was not only hurt, but oneself had done the hurting, in imagination even if not in fact.

I found another drawing which developed the idea of the deadness of reason and logic when separated from feeling (Fig. 36). It showed a mixed male-female creature; the head seemed to be the male part, spouting from its mouth a thundercloud and black lightning, and the body the female part, round and full of seeds. I had not before written down the ideas which belonged to it, I think I had not dared to. But now I tried:

'The head is a clown's head, it wears a clown's collar and has a silly little red beard and red sprouts of hair and a red nose. And the thundercloud has red veins in it, like that little red parasitic plant which grows in heather, it's called dodder—O Lord, that's what the drawing says, the doddering male! And the thundercloud also reminds me of the thundercloud God of the Angry Parrot picture, also of that time when I suddenly saw Blake's picture of God creating the world with a geometrical instrument, "The Ancient of Days", as a drunken clown looking down from heaven. The thread-like feathery things coming out of the clown's mouth are like stinging feelers, stinging words. The blackness of the thundercloud and the black lightning make me think of abstract words, intellectual discussions, how they so often seem black and dead, none of the colour and life of words when they are used to describe particular things. The fish on the right is going to burst the balloon up above, it makes me think of how Charles II burst the balloon of the learned men's arguments about the fish when he said, "Is it a fact?" The round body full of seeds reminds me of how I used to think there was an insoluble dilemma for women, "brains versus babies".'

FIG. 36

Here the imposed order from above, and reason, as dependent on abstract words, and maleness, and the wrath of God, seemed all to be identified. In fact the drawing seemed, amongst other things, to be mocking at the mathematical God idea of the physicists, but a mockery that covered fear.

Having seen that all these drawings presented various problems in a rigid either-or form, there was now this whole question of distinguishing differences to be considered. Certainly the particular distinction between thoughts and things was something I had often wondered about. I had often thought of the great undertaking every child has to achieve in coming to recognise that thoughts and things are different. I had thought about it also as a matter of history, what life must have been like before the development of objective science. It would have been so easy then to believe in magic and the evil eye, so easy to give up the task of observing and finding out where one's practical knowledge was at fault, to relapse instead into feeling oneself the innocent

victim of the bad spells and animosity of the witches; and so easy to be content with reciting a spell oneself instead of doing the hard work of finding out. In short, how true it was that

> '... if we do not know our environment, we shall mistake our dreams for part of it, and so spoil our science by making it phantastic, and our dreams by making them obligatory.'
>
> Santayana: 'The Supreme Poet', *op. cit.*, p. 154

Yet at the same time it might also be necessary to recognise that we have to pay a price for this achievement. I thought I had learnt, in general, how to look on the world with an objective eye, how to use a narrow focus of attention which shuts out the overtones and haloes of feeling and subjective seeing and keeps itself apart from what it looks at. Or rather, I realised now that I lived with a perpetual sense that one ought to look in this way, there seemed to be something always trying to insist that one should keep on the scientific blinkers and see only the clearly focused objective facts, shutting out the world as seen from the corners of one's eyes. But it seemed that something else was continually demanding freedom from the blinkers, at any rate at times, insisting that to be without them did not necessarily mean to be mad and see things that are not there. Thus I was being driven to recognise that scientific objectivity was only a partial aspect of one's relation to the world, and that both ways of looking were sterile without each other. In fact, one had to stand apart in order once more to come together again in a restored wholeness of perception.

I could now also see why I had thought of reason as dead and had had to put the mathematical symbols on a tombstone. For at that time I had not yet discovered the wide embracing kind of concentration that gives of its own identity to the particular nature of the other. I had not yet discovered how to link general and abstract ideas to particular ones, for I had not yet discovered the rhythmic interchange of the two kinds of attention. I had still thought that the analytic narrow-focused kind of attention was the only deliberate kind there was, and that deliberate logical thinking was the only kind of thinking there was. And the result had been that most of the vital experiences of living, which cannot be apprehended by the narrow-focused kind of attention, were left unthought about and only blindly lived. For I realised now that the main experiences, main facts of human life which we have to learn how to adjust to are living facts, people, both others and ourselves, living particular wholes existing in their own particular identity. And particular wholes can never be apprehended in their own

individual nature by the narrow-focused analytic reasoning power alone; it required the same wide embracing spreading of one's own identity, to apprehend the unique reality of a person as of a picture.

This antithesis of two kinds of attention could also be thought about in terms of the antithesis between male and female ways of being. Such an idea had been hinted at in the Dodder-Clown drawing and was

FIG. 37

further developed in another called 'The Turkey-Conductor' (Fig. 37). When I had drawn it the first thought had been a quotation from Blake:

> 'Thus one portion of being is the Prolific, the other the Devouring. To the Devourer it seems as if the producer was in his chains; but it is not so, he only takes portions of existence and fancies that the whole.
> 'But the Prolific would cease to be Prolific unless the Devourer, as a sea, received the excess of his delights.'
>
> *The Marriage of Heaven and Hell*

But now it occurred to me as significant that the two figures of the turkey and the conductor, in representing the male and female, were back to back instead of co-operating in creative action; with the

result apparently that the turkey cannot give birth to her precious egg, and the conductor has no face and is conducting an audience that is not there.

Thus it seemed that this last set of drawings was concerned with the idea that there is a tendency of the mind to make broad distinctions, to split problems viewed into two extremes, and that the splitting is necessary. Certainly one has to make the distinction between dreams and reality, for instance, or between outside and inside, body and mind, doing and thinking. But having done that it is then necessary to bring the two halves together again, in a complex rhythmic interplay and interchange. And the method of the free drawings illustrated both this interplay and also its surprising results.

IDEALS AND THE FATAL PREJUDICE

'We see experience as an interplay of forces, as the activity of relating leading through fresh relatings to a new activity, not from purpose to deed and deed to purpose with a fatal gap between, as if life moved like the jerks of mechanical toys with only an external wirepuller to account for the jerks, or a too mysterious psychic energy. . . . Activity always does more than embody purpose, it evolves purpose.'

Follett, pp. 81, 83

UNDOUBTEDLY the themes of the last set of drawings had shown that one's mind could be very concerned with this problem of differences; but also that it tended to run to extremes and having once distinguished opposites then it tried to keep them rigidly apart. Also, if I had interpreted such drawings as the Angry Ape aright, this was partly because of certain painful and intense emotions connected with earliest experiences of difference, particularly the first perceptions of the difference between what one would like and expect people to do and what they do do—in fact, the first experience of the discrepancy between dream and actuality. Of course I knew by now that this again was a central part of psycho-analytic theory: that the childhood spectacle of the parents together and oneself shut out could become a kind of prototype of the difficulties to do with the recognition of difference. I knew the theory that jealousy and fear of the creative activities of the parents can often make it very difficult to believe in creative interplay in general. But the particular part of the problem that psycho-analysis had not so far made clear to me was to do with this creative interplay between dream and external reality.

There was one fact which it was very difficult to keep firmly in mind; this was that both the internal dream and the external reality had value in their own right, provided that they were not kept rigidly apart. I could tell myself intellectually that one's dreams are one's own creations, something that one has fashioned out of the vivifying contacts between nature outside and nature within. I could tell myself that we cannot help but dream, completing in imagination the pattern of our necessarily fragmentary experiences of the external world, we

cannot help working over in our imagination what happens to us, creating internally the ideal wholeness of what the experience might have been; just as we continually complete the wholeness of the unseen three sides of a cube and recognise it as a solid in our everyday experience of perceptions. And I could tell myself that without such dreams, or expectations of experience refashioned out of memory, our lives would be entirely purposeless and blind. But all the same, I still caught myself using the phrase 'only imagination'. And I was also at the same time continually caught up in the opposite extreme of so over-valuing the imagination and disparaging the external reality that it was sometimes very difficult to attend to what was going on externally at all. Also although I could tell myself that the inner dream had to be continually tested and enriched by the contact with external reality there still seemed to be great difficulty in letting them meet. There seemed to be a profound fear of losing something; and I realised now that it was not an entirely groundless fear. One did in fact lose something, and one had to face this loss, even though one did in the end gain something so much greater.

FIG. 38

There was one drawing which seemed to be depicting the fact of this loss and gain, particularly in connection with those aspects of our dreams which are usually called ideals. It was called 'The Eagle and the Cave-man' (Fig. 38).

'Those little figures are suspended above the earth by curious square balloons, like Chinese lanterns which look as though they are beginning to crumble. Also there are brick-bats flying about and then also the eagle is just going to fly across the supporting strings. Altogether I think the mannikins hanging on to the lanterns are going to have to come down to earth pretty quickly. And what are they going to find there? Footsteps of a cave-man who has emerged out of a crack in the mountain and gone along to the fire. But there are no footsteps away from the fire, I wonder where he has got to? I do believe he has plunged into the fire and emerged again as the eagle. What's an eagle? A bird that sees. It seems to be the power of seeing that is destroying the mannikins' aethereal supports and bringing them down to earth. I always did feel that hitching one's waggon to a star might end in hanging most uncomfortably in mid-air.'

In one aspect this was a continuation of the argument of the N.B.G. drawing, a pictorial comment on the too extreme division shown there into spirit-flesh, things-above-things-below. Thus I thought the eagle picture was saying that to stop looking to the sky for one's supports was not necessarily to lose all that distinguishes one from the animal and the cave-man; and in saying this it did seem to show a step towards willingness to bring dreams down to earth and letting them interact with the facts. I thought also it showed a growing realisation that to be so 'indirect and lumbering' that one confused the spiritual reality of the internal dream with what in fact can be found externally was a fatal idolatry. Such a confusion must surely lead to an inner tension that was intolerable; to escape it one would tend either to distort the facts and pretend they were better than they actually were, giving everything a rosy light; or else one would degrade the dream, turn against it and deny that one had ever loved it or that it had had any value. In fact I saw now that disillusion, opening one's eyes to what are called the stern facts of life, meant recognising that the inner dream and the objective fact can never permanently coincide, they can only interact. But I saw also that in order to do this one has to reckon not only with one's hate of the external world, when it fails to live up to one's expectations, but also hate of oneself when one similarly fails. Thus the same problem of the gap between the ideal and the actual applied within oneself, the gap between what one is and what one would like

to be. Certainly I had long been aware that failure to recognise the inevitability of the gap led to much self-deception and fruitless straining. But what I found now was that, at times, if one could bring oneself to look at the gap, allow oneself to see both the ideal and the failure to live up to it in one moment of vision, and without the urge to interfere

Fig. 39

and alter oneself to fit the ideal, then the ideal and the fact seemed somehow to enter into relation and produce something quite new, something that had nothing to do with being pleased with oneself for having lived up to an ideal or miserable because of having failed to. In fact it almost seemed that the wide-seeing eagle of the drawing was a way of saying something about a growing belief in a certain watching capacity of the mind; a watching capacity which, when separated from

the interfering part, became the light that could meet darkness and redeem the denied greeds and hates and despairs of the bodily life. For it was a watching part which, by being able to see the two opposing differences of standard, or ideal, and actuality, in relation to each other, was by this very act able to bring about an integration, a new way of being which somehow combined the essence of both.

It now occurred to me that in fact this watching capacity of the mind was depicted in some of the other free drawings, only I had not recognised it as such. For instance in the Angry Ape (Fig. 21) there had been a woodpecker looking on. Also I found one drawing which showed a many-eyed insect with stunted wings (Fig. 39); and this reminded me of the fact that there are people who complain of something in themselves which seems to be always watching and criticising what they do and making them feel that they want to escape from its watchfulness. But supposing one could accept this watching capacity instead of trying to push it into the background. Supposing one could let it develop from an ignored woodpecker picking holes in a tree to a wide-seeing eagle able to see the whole countryside; supposing one could strip from it its interfering and destructive aspects, supposing one could accept self-knowledge, with all its implications, then, if I could believe my own experience, an entirely new way of living opened. It was a way of trying to manage the primitive impulses which was quite different from anything I had been brought up to believe in. So many of us are taught the way of offering the cave-man within us a model or exalted set of standards of how he ought to behave and then brow-beating or cajoling him into copying them as best he can. I had even thought that this was how one would produce pictures. I had intended something great and beautiful and studied the rules and then expected the result to follow from the excellence of the intention. But always the result had been, both in painting and in living, a sense of emptiness and futility. Was this perhaps what a painter meant when he said:

'No more good will come of giving people a lot of rules for looking at pictures than of telling people how they should put art into their pictures. In each case a fatal prejudice is introduced.'
Graham Bell: *The Artist and His Public*, p. 28

Was this why, in *Pilgrim's Progress*, Christian could find no help in the town of Legality and imposed moral codes, why the fires and terrors of Mount Sinai nearly destroyed him altogether? In fact, it seemed that the difference between the two methods of control was

that the second turned the moral struggle against greed and possessiveness in oneself into quite a new direction, it did not demand a labouring to acquire virtuous qualities of unselfishness and such, or deliberate efforts to live up to ideals of behaviour, with all the accompanying dangers of dishonesty and trying to excuse one's failures and make out one is better than one is. Instead, it pointed to an undaunted determination to know the worst about oneself, not in order to wallow in self-punishment and despair, but because in fact something quite surprising happened, like the breaking down of a prison wall. The phrase 'resurrection of the body' kept coming into my mind, and I thought of Stanley Spencer's picture, 'The Resurrection', in which all kinds of people are climbing out of their graves into the summer morning of a country churchyard, looking dazed with unbelief that such a thing could be.

But if willed effort to create a 'good' picture or a 'good' person only, so far as I could see, led to something which had a counterfeit quality, surely this did not mean that one should never try to learn what a good picture or a good person was like? It seemed rather that one must do two things. One must certainly work at hammering out internally one's ideal, know as far as possible what one wanted or liked. But then one must forget it, plunge into a kind of action in which the acting and the end were not separate, something which perhaps Traherne was thinking about when he said:

'It acts not from a centre to
Its object as remote,
But present is, when it doth view,
Being with the Being it doth note;
Whatever it doth do,
It doth not by another engine work,
But by itself; which in the act doth lurk.'

Here I thought of Alice who, when she wanted to get somewhere, found she had to walk in exactly the opposite direction. Also it now seemed possible to say more about where the learning of the rules did come in, in learning how to paint. For the beginner, the chief obstacle emphasised is his lack of skill in managing his medium. Thus he is often expected to spend a long time discovering and learning the laws of optics, finding out how certain arrangements of shapes and colours produce certain regular effects on the eye. If one is going to be a professional painter probably this is all right. But for the Sunday-painter I thought it was not at all all right, at least not for me; for one might

spend a lifetime of Sundays and get very little way, if one did not also consider how to become more used to taking the plunge, more able to throw the rules to the winds and forget the separateness of oneself and the object. I thought of children's drawings in this connection, how often with so little knowledge of proper methods of depicting visual experiences they can yet take the plunge and the results delight us. Probably they can do this because the plunge is less of a plunge to them, since they live so much of their lives, through play, in a state where dream and external reality are fused; it is a familiar element for them, they are like birds and can live both on land and in the sky without complicated machinery to get there.

Now I could also say something about the Eagle and the Cave-man picture in connection with the method of the free drawings. For it seemed that the still poise of the hovering eagle did really stand for that peculiar kind of concentration that had produced the drawings. It was a kind of active stillness of waiting and watching that embraced both inner and outer, subject and object, sky and earth, in a unity which yet recognised duality.

So also it now seemed that the young dragon of the 'Rats in the Sacristy' was not altogether mistaken in shying off from the red ball: that is, if the red ball meant trying to live as if one's thinking mind were entirely separate and self-enclosed, if it meant trying to live without ever being united with what one looked at.

Having arrived so far, it now seemed possible also to say more about those moments of transfiguration which had appeared so out of keeping with common sense reality, moments in which apparently the inner and outer became fused in the transfigured object; for it now seemed likely that these moments need not always be dependent on circumstances entirely beyond one's own control. I had once heard a painter say that whatever the scene or subject, when he settled down to paint he then gradually became enamoured of the subject and the transfiguration would begin. Certainly I had once found something of this sort happen, not in painting but in early experiments in concentration exercises; I had sat down before an ugly white tin mug and meditated upon it, and gradually found an absorbing excitement in the gradually growing sense of its 'thingness', its 'stresses and strains', in fact, the sheer 'thusness' of its existence in space. But usually, when trying to paint in this way, by attending to the object to be depicted, I forgot the wide concentration of the hovering eagle and got caught up in a mere dry statement of appearances so that the picture became more and

more dead. In fact it was not until after I had considered more fully the use of the free drawings (see Chapter XIV), that it became possible to understand more of how this deadness of the picture could arise, more of how the unmitigated objectivity of an object in front of one could actually seduce the mind away from the proper balance and interplay of inner and outer. Thus I did not yet understand how, at certain stages of trying to achieve this interplay, the growing mind could only manage very small doses of objectivity, perhaps only the amount that was here represented by the pencil and paper in contact with one's hand.

RHYTHM AND THE FREEDOM OF THE
FREE DRAWINGS

'Every living process is subject to its own authority, that is, the authority evolved by, or involved in, the process itself.'

<div align="right">Follett, p. 206</div>

'On the level of personality I gain more and more control over myself as I unite various tendencies. . . . We can always test the validity of power by asking whether it is integral to the process or outside the process.

'And is not power, thus defined, freedom—freedom and law too? In the life process freedom and law must appear together. We can see that when we unite opposing tendencies in ourselves, the result is freedom, is power, is law. To express the personality I am creating, is to be free. From biology, social psychology, all along the line, we learn one lesson: that man is rising into the consciousness of self as freedom in the forms of law.'

<div align="right">Follett, p. 193</div>

HAVING BEEN brought to face the fact that there was apparently another kind of order, different from that imposed by conscious planning and willed activity towards a foreseen end, it was now necessary to try to find out more about the non-willed kind. The best way to approach it seemed to be through the matter of rhythm in painting.

Once I had wanted to draw a cat but had found it too difficult and had made a written note instead:

' . . . that little cat playing with a fish-bone in the gutter, it's like a panther, it calls up echoes of dark jungles, I don't know how to express that idea in terms of the lines of the cat's body, I feel it as images of huge trees and jungles and remoteness, a far-away-in-Africa feeling.'

I had gathered from reading that such associated ideas evoked by looking at an object were called 'literary' and were not the essence and core of painting although they had a secondary usefulness in the task of communicating emotion. But at that time I did not understand at all how to make the lines and shapes and colours, simply by the pattern they made together, produce a direct emotional effect, one that

was apart from what objects of the external world were actually depicted in the drawing. In fact, I did not then understand in what sense painting was a sensory organic language rather than an idea language. It followed also that, although having often enough come across the word rhythm in books on painting, it had never seemed quite clear exactly what was meant. Now, however, being brought to face the problem in connection with the idea of non-willed order, I did find a fairly precise definition:

> 'The word rhythm is here used to signify the power possessed by lines, tones and colours, by their ordering and arrangement, to affect us, somewhat as different notes and combinations of sounds do in music. . . . The danger of the naturalistic movement in painting in the nine-teenth century has been that it has turned our attention away from this fundamental fact of art to the contemplation of interesting realisations of appearances. . . .
>
> Speed: *The Practice and Science of Drawing*, p. 127

This seemed clear enough, but I was a little disconcerted to find, by the pencil markings in the book, that I had read this passage before but had apparently forgotten all about it. What was there about rhythm in painting that made it so hard to understand? What was there about the difference between a sensory organic language and an idea language that made it so difficult to think about? Was it more than the strength of an unrecognised nineteenth century influence? I found that a series of my own sketches certainly illustrated the differ-ence, even if it did not explain it. For the first version of the sea-wall sketch, which was realistic (Fig. 11 *a*) had as it were merely referred to the sea-wall as an idea, but it had not satisfied the impulse to draw, so I had felt impelled to experiment further and also to make a diary note.

> ' . . . with the fourth version (Fig. 11 *b*) it seems the balance of line and mass that has become the most interesting, not so much the sea-wall as such, it is the heave of that great stone groyne running out into the sea, the weight of it, the encircling quality, as if I had worked through from an idea problem to a muscular feeling problem; though perhaps still dealing with the same essence, the control of upsurging movement, trying to make that great heaving point of solid stone into something balanced, something that stays within the picture.'

Thus the choice of that particular landscape as subject for a sketch seemed to have been determined in the beginning by an association of ideas. If the theory put forward here was correct it was largely the symbolically presented problem of the overlap of inner and outer that had determined the choice of subject, in fact, the problem of illusion

that was just beginning to draw attention to itself. But it also looked as if the inspiration of the drawing had developed with the action of the drawing and had become more purely pictorial, more concerned with the inherent emotional quality of the rhythm and sweep of line.

It now appeared that the difficulty with rhythm was not only a private one, for I read:

> 'Those harmonic qualities which to some extent painting shares with music enter, as yet, very little into or perhaps even have been lost from the awareness of the ordinary man.'
>
> Cora Gordon: *Art for the People*

Certainly I had had ample experience that it was a very potent force; for it felt like suddenly emerging into an entirely new world whenever I did manage to become conscious of these rhythmic dialogic give-and-take relations between different items in a picture. But if so potent, why was it lost or else never achieved in one's ordinary consciousness?

In order to answer this question it seemed necessary to find a further definition of rhythm, one that would be comprehensive enough to include all its aspects. What was needed was one that included the idea of a repeated and ordered interplay between differences and samenesses, whether the samenesses and differences were to do with sounds or movements or physical processes or lines and shapes and colours. But this emphasis on repetition brought with it the thought of the difference between a repetition that is living and one that is dead. I knew that the tendency to repeat experience was looked upon as one of the ultimate qualities of living matter, since all creatures, other things being equal, tend to go on behaving in the way they have behaved in the past; and also that this tendency to repetition was an essential aspect of growth, provided that it was balanced by its opposite, the impulse towards change, variety, new experience. But the two principles, repetition and variety, are discussed in most books on painting. I even remembered being given these two words in a lesson at school on pattern and design, though at that time I had thought the distinction dull and academic. Now, however, it seemed deeply important, a matter of creative life or death; for if repetition was not vitalised by the continual marriage with variety it became utterly dead, like my drawings from nature which were sheer copying, and if variety was not held in check and made coherent by repetition it became chaos, as in the free drawings that were mere scribbling. The difficulty in the happy marriage of these two, however, seemed to be that there were other factors weighting the two sides and liable to

upset the proper balance. For in addition to the deep impulse to rhythmic repetition inherent in our being there have been, for all of us, external rhythms and rules imposed by authority and the clock, by bells that ring at school and daily trains to be caught. Thus repetition could become associated not with the deepest springs of our own vital processes, a living form of inner coherence and control, but with something alien imposed from above, the submission to which might seem to involve the loss of one's whole spontaneous life. While variety, on the other hand, with its breaking away from the repetition of routine, could come to stand for the spear-point of one's own will and identity. It occurred to me now that the row of creatures in

FIG. 40

Fig. 15, who might be cooks or nurses holding the demanding bottle, perhaps stood for the same idea of a deadening routine. And there were also various items in other drawings which suggested that the idea of deliberately repeating an experience or accepting a rhythm could involve thoughts of danger; for instance the danger of being hauled back over the abyss into that dark murky river where the separate will is lost for ever (Fig. 33). In fact, repetition could mean the overwhelming and drowning of the spirit in blind repetitive instinctive life. I found another image of this danger in the symbol of entombment in a catacomb of rock (Fig. 40). It was not a free drawing but an attempted copy of a half-waking image, one which had appeared just before being plunged into the overwhelming instinctive experience of childbirth.

This difference between a repetition that is living and one that is

dead provided another example of the either-or tendency, the tendency to separate and isolate aspects of the living process which should be in active relationship. Thus such a fear of the individual will being lost in the blind repetitive habit life of one's animal inheritance was probably increased by just such a splitting, one which only made the will more 'up above' and tyrannical and the instincts more earthbound and turgid. But although such an excessive splitting was undoubtedly uncomfortable, perhaps it might be an inevitable temporary state, a necessary phase in the great struggle of conscious awareness to develop out of blind organic life. Certainly the difficulty of becoming conscious of the effects of rhythm in painting felt like a struggle with a very primeval force. Also it seemed now that this struggle might have a real basis in the fact that control by rhythm and control by self-conscious willed endeavour are mutually exclusive processes; as illustrated in the story of the centipede who could not walk at all when he tried to answer the question which foot he put forward first. Thus to allow a rhythm to develop in one's hand movement when drawing or even in one's perception when looking at a picture, did seem to require a temporary throwing to the winds of the dominating will, it involved a kind of plunge which one's ordinary consciousness could dread. And it could be dreaded in spite of the repeated experience of the rewarding delight and freedom that giving oneself up to the swing of the thing can bring.

The more I thought about it the more profound the issue became; thus it seemed that the blind instinctive repetitive rhythm, which was one term of the two deepest urges of one's organic existence and which could be such a source of refreshment and renewed life, could also, in its extreme and isolated form, represent death. And apparently it could also become associated with that alien 'law' imposed from above, which in the free drawings was symbolised by the castle and the ice-demon and the thundercloud god. Further aspects of the matter also emerged when I began to think about the word 'form' in connection with the arts. Just as with rhythm so with this word form; up to now I had found great difficulty in thinking about it at all, and the same conflicting feelings were aroused. Just as it is routine, habit, regularity, ceremonial, formal procedure that stems the impetuous rush of instinct and the capricious wilfulness of immediate desire, so also it is form, shape, pattern, that makes possible any coherent emotional relation to the external world at all. It is by the form of objects that we recognise them, by their shape; a world that is without form is indeed void,

there is nothing in it to get hold of; for any external object to become happily significant for us it must have some form by which we can recognise it as likely to satisfy our needs and therefore as relevant to our destiny. So here again surely was the original problem of the Angry Parrot, here was the principle of limitation, outline, patterning, the ordering principle which could be both hated for its restrictiveness and yet loved because utterly needed for one's very psychic and physical existence.

FIG. 41

Such ideas now made clearer the meaning of the drawing called 'If the Sun and Moon should doubt . . .' (Fig. 41). Its story was:

> ' . . . the shapes at the bottom are waves, the sea of feeling again I suppose. Those two whirlpool-like things to left and right seem to be gramophone discs and those three small pillars on the top left are books, my books. The curious flying buttress shapes make me think of architecture and the flat thing at the bottom somehow suggests a spirit-level. It's odd, I hadn't thought of that before but I do get a kind of levelling of the spirit when I look at a lovely building. I did not see that the drawing had any associations at first, but now it does seem to do with achieving some sort of balance by expression, whether in words or shapes or music. And the title
>
> > "If the sun and moon should doubt,
> > They'd immediately go out."
>
> that makes me think of the doubt which means doing nothing for fear of the badness of one's efforts, of being unable to draw because of being unable to see ahead what would come, unable to trust in any

order in the result. It reminds me of the Castle of Giant Despair where Christian was tempted to suicide. And the spiral theme, both in the gramophone discs and the corkscrew thing on the left, a spiral always seems to be somehow ordered from inside itself.'

Undoubtedly the sun and moon here did mean the ordering and life-giving principle: that is, in the beginning, the parents. But I suddenly saw from the story that there was a reversal in the title: 'If the Sun and Moon should doubt . . .' meant, for me at least, that if I should doubt the sun and moon I would go out. So it seemed that the thought behind the drawing was an elaboration of the ideas in the earlier ones. It was that if the hate of the restricting and frustrating parent figures becomes too great and is therefore denied they are then felt in imagination to be either destroyed or turned into avengers, they become the giants of the Castle of Despair. Then all belief in one's own creativeness can fail; one can psychically go out just because of having lost belief in any non-willed order. But by its emphasis on control through an inherent rhythm this drawing did suggest that there was a way of mitigating the original hate of the imposed order.

I found three pictures which seemed to be a kind of graphic reflection upon this problem of the two kinds of order, the imposed and the inherent:

> (Fig. 42) . . . the little man is doing what he is told, he has a termagant wife inside the house who has sent him out to mind the baby. The little dog, walking in the opposite direction, has just pee'd on the lamp post.
> (Fig. 43) . . . those three figures are drunk and a bit crazy, the middle one looks like the Mad Hatter. On the left is a bonfire, they have made it out of books.

Fearful subservience to an imposed authority either inside or out, or complete abandonment of all controls, neither of these was the solution. The little dog, however, provided a hint of a third way, for he was neither running amok nor resentfully subservient, in fact his controls seemed to be gaily within himself. And this last theme was developed further in the third sketch (Fig. 44).

> (Fig. 44) . . . the flattened figure eight in the middle seems to be a gramophone record, though a rather battered and misshapen one. The three little mannikins that are dancing upon it, leaping and spinning to their feeling of the rhythm of the music, have an exuberance that is not the extravagant abandon of the Mad Hatter, it is a controlled exuberance, controlled by an inner sense of rhythm and repetition and form.

FIG. 42

FIG. 43

FIG. 44

Certainly such an inherent form of control did seem to offer a way out of the predicament of the Angry Parrot. For the inherent form, in contrast with control through subservience to an authority, whether inner or outer, must surely reduce both fear and hatred. It reduced fear of separation and of the chaos that would happen if one lost contact with the external controlling force: but it also reduced the need to hate the controlling force for its interference, because one need no longer rely on that interference. The parrot need no longer hate the Grey Woman because it will no longer need her to save it from the tumultuous waves of feeling, it can in fact deal with the waves itself, it can 'in the destructive element immerse' with safety and need no longer be a kingdom divided against itself.

The figure-of-eight drawing, with its dancing figures, also embodied the idea that the spontaneous order, in contrast with the imposed, is essentially the result of free activity. It made me think of how, in spontaneous ordering, the impulses to be controlled become themselves changed because they are fitted into a pattern of wider context and meaning, through the fact of doing something. The authority way of ordering, including so many sermons, says: 'You must love your parents, love the good things, hate the bad things'; but the other method does not *say* anything, it simply offers activities by means of which the love and the hate become attached to the good or bad things, through the spontaneous pattern-making associative powers of the organism in action. All parents and teachers know about this activity method of control, they give unruly children something to *do*, so that the disruptive impulses become changed by fitting into a context beyond themselves. And I thought that the arts do the same, they never say 'This is what you must love and therefore serve and cherish and protect, this is what you must hate and therefore avoid, get rid of, change' as moral teaching does; instead, they try to express the loveliness or hatefulness of things so that you cannot help loving or hating them. And I thought such a view of the meaning of the arts held good both for creation and appreciation; since in creative activity one is doing it for oneself, trying to find an order in one's own loves and hates, and in appreciation one is observing how someone else has tackled the problem and sharing their experience imaginatively.

Now it was necessary to ask another question. If there was in fact this other kind of order which resulted when deliberately willed intention and conscious working to a plan was eliminated, had conscious planning no function at all?

If it were indeed true that one could not hope to create either a genuine picture or oneself as a genuine person, solely by will-power and imposed rules, where did will-power come in? It looked as if the answer to this might come from once more considering the free drawings and their method. For although I had not decided 'This is what I am going to do' and done it, there had been some deliberate action involved. Although usually at the beginning the drawing was done on impulse, it was afterwards necessary to impose action according to plan, at least to the extent of forcing oneself to go on drawing in spite of not knowing what was going to appear. And not only did one need will-power to keep one's hand moving on the paper, but also by will-power one had to maintain the kind of attention which created a gap ahead in time and a willingness to wait and see what was emerging to fill the gap. Also to do this one had to shut out internal or external interruptions which might lead one's thought away from this framed emptiness ahead.

Here then seemed to be a possible hint as to the role of will-power, both in painting or in any producing of something new. Obviously one could not plan beforehand exactly what was to be produced, for if one knew beforehand it must surely be a repetition of something that had been before. But what one could do was plan the gap into which the new thing was to fit. If it was new knowledge one was looking for one could plan the question, frame the question, work on deliberately planning the empty space into which the new knowledge was to fit. Or if it were a new invention, a new way of doing things, one could specify or plan beforehand the practical need that the invention must satisfy; even though before inventing it one obviously could not say what the exact nature of the solution of the problem would be.

So if one tried to define the real function of will or planning in creative activity was it perhaps something like this: was it possible to say that the business of the will was to provide the framework within which the creative forces could have free play? It is said that no art school can teach you how to paint, in the real sense. But the art school can and does provide the frame, it offers regular times and places and materials for creation. And by the willed act of registering as a student and attending at the proper time one can, as by a protective frame, free oneself from the many distractions of trying to paint at home.

Such a view of the role of the will in creative activity surely was also relevant to the issue in the political world between the planners and the

anti-planners. It suggested that both were right in different ways, both wrong in denying the rights of the other. Obviously the foreboding of those who fear planning, that all spontaneous endeavour and creativity will be stunted, is well founded, if the planners fail to understand their true function. If they overstepped their function of providing a secure frame for the free activities and tried to dictate the activities themselves, then there would certainly be sterility and deadness. But also the planners were right in their fear of chaos and its destructive results, in their realisation that without a definite frame human activity can spend itself in a disastrous dissipation of energy and failure of the opposing creative forces ever to confront each other.

Thus I could now say that the freedom of the free drawings was not the illusory freedom of Fig. 16, not the 'freedom' of thinking one has got rid of all restraint, which ultimately means being the slave of blind instinct. It was rather a freedom resulting from having entered into active relationship, from having recognised the necessity of difference and from having allowed the two differences, dreaming and doing, a maximum of interplay.

THE CONCENTRATION OF THE BODY

> *'With my body I thee worship.'*
> Book of Common Prayer

> 'This reciprocal freeing, this calling forth of one from the other, this constant evocation, is the truth of "stimulus and response". I object to calling physiological stimulus and response the "material" part of life. We find the same life-process—the self-yielding of organism and environment—on every plane; here in the concrete circumstance is the "living" truth. Where then is reality? In the objective situation, or in "the people"? In neither, but in that relating which frees and integrates and creates. Creates what? Always fresh possibilities for the human soul.'
> Follett, p. 130

WHEN THINKING about the kind of concentration required for making the free drawings I remembered reading:

> 'It is no good at all to look at the model as if he were a jug, and try to draw him as such. Having looked at the model and having understood his movement as well as possible, you must then place your *subconscious* self in the same position. In your own *imaginative* muscles you must be able to feel the strains of the model's pose.'
> Jan Gordon: *A Step Ladder to Painting*, p. 206

I had also read:

> 'For the creation of works of art there is a condition of the spirit that must be achieved and preserved at all costs. This condition can be compared to what the religious term a state of grace. It is a state of exaltation, of communion with life, nature and his fellow beings which enables the artist unconsciously to exalt, re-create and transcribe the world about him.'
> Dunoyer de Segonzac

In a small way the kind of concentration which had produced the free drawings did seem to be a state of grace in that it often did not happen, the dialogic interchange was often not achieved, some essential condition of the spirit was lacking. But when it did happen, although it was certainly a condition of the spirit it essentially also encompassed the body. For the making of any drawing, if it was at

all satisfying, seemed to be accomplished by a spreading of the imaginative body in wide awareness and this somehow included one's physical body as well as what was being drawn. I found a diary note:

'... this satisfaction in gaining awareness of the object as a whole, through use of repetition and rhythm of symbol, is like the feeling that exercise gives, particularly dancing or skating. In drawing that tree, the spread of the branches and leaves gives an awareness of my shoulders and arms and fingers and I feel its roots in my feet.'

There were also many problems to do with what actually happened when one did succeed in making the imaginative body encompass the physical body. There were questions, for instance, of the kind of experiences the enhanced body awareness included: such as feelings of weight and spatial position, of up-ness and down-ness, of right and left and three-dimensional spreadness, of balance and uprightness and every kind of movement. Clearly this was the set of experiences, with their associated memories and dreams, which distinguish the visual arts from the literary ones, for instance, and they also threw light on my specific problem of how to express the idea about a cat playing in the gutter in graphic rather than in literary form. But if these body dreams were to do with all one's experiences of movement and posture and internal physiological states they were therefore intimately connected with one's emotions. Here I thought of Darwin's *The Expression of the Emotions in Man and Animals* and of the infinite variety of postural change which is the instinctive aspect of the expression of feeling. I thought how ordinarily this is inhibited in most of us; in our social life, after childhood, we do not jump for joy or kick and stamp with rage, we do not prance for pride and exuberance of life. So surely all these inhibited bodily impulses expend themselves in body dreams, our inner world must be full of dream postures of the body in which the instinctive mood is unfettered. In music perhaps we get nearest to knowing these consciously, or some of us do, and in dancing they are made explicit in actual bodies. But I thought painting also, though less consciously, taps this rich source of body dreams and finds in what painters call the action of the picture a most potent way of affecting our feelings. I remembered now how some of the first drawings made out of my head, before ever discovering how to do free drawings, had been a series of schematic representations of bodily postures expressing emotion (Fig. 45 *a*); and there had also been another done later as a free drawing (Fig. 45 *b*).

FIG. 45 (a)

FIG. 45 (*b*)

There was one drawing which touched on this idea of conscious-
ness suffusing the whole body, and also on the effects of that narrow
non-embracing kind of attention which cannot by its very nature
encompass a wholeness. It also depicted the way in which such narrow
focus can shut out parts of oneself, part of one's wishes and feelings
and how such shut-out parts can remain primitive and cruel (Fig. 46).
The story of the picture was:

> 'It is a two-faced creature, the dog part is sitting up and waiting to
> do what he is told, the cat part is taking no notice of authority, in fact
> turns her back on it, to play with a mouse and rudely sticking her tail
> up in the sun's face. The animals all round seem to be one's own
> products, possessions, children. But in one sense I think they are
> moods, crabbiness, being the black sheep, or the little pitcher with
> long ears, or being submerged in day-dreams like the sea-horse under
> the water. It's like the determination to be oneself, like the rich lavish
> feeling in childhood of having one's toys spread all round one on the
> floor.'

In one sense this picture seemed to refer to all the years one could
spend at school in dog-like obedient and narrow-focused concen-
tration on the face of the teacher, shutting out feeling and impulse

and trying to be what is expected of one; though it looked as if all the time the cat part of one's nature could be looking the other way and cruelly playing with a mouse. Also one special thing to be noticed about it was the way the drawing itself made its own frame, except for the cruel claws and the mouse which almost seemed to be coming out of the picture altogether.

FIG. 46

Incidentally this reminded me of how difficult it was, when trying to make a picture deliberately rather than by the free drawing method, to keep in mind the frame and to fill the space within it harmoniously. The items in it always seemed to get arranged in a lop-sided way and to leave certain blank spaces which needed to be filled but I would not know what to put in them. So it looked as if the narrow-focused obedient monologue kind of attention, which shut out wandering thoughts and rebellious moods, which was the kind of attention I had so long thought to be the only kind, made it both impossible to create a picture with properly balanced items within a frame; and also impossible to create oneself as a properly balanced whole of integrated moods and desires within a body. In fact, the drawing seemed to depict the inability of the narrow pointed concentration of obedience and reason to educate the emotions, it showed how the destructive wilfulness can

exist in all its primitiveness, side by side with a conscious attitude of obedience and co-operation.

Such a state of total body concentration in which the imaginative body suffused the physical body was connected with a special image, and I now realised that this had in fact already appeared before in the Angry Parrot drawing. In this image it was as if an egg-shaped sphere, slightly bigger than one's physical body, could totally envelop it, envelop it cloudily yet also with a hint of smouldering fire; in fact here I felt was another aspect of the parrot's egg, only there the parrot was outside it instead of being enveloped in it.

This linking up of the parrot's egg with the high point of creative body concentration now also led me to see certain aspects of the Angry Parrot's dilemma which up to now had been obscure. It threw light on some possible effects of scholastic education and the ways in which one is expected to acquire the art of concentration through school learning. The clue was that the Grey Lady of the Angry Parrot picture in part represented a famous head-mistress who had once taught me; for now I saw that the parrot's fear of losing its precious egg was in part a fear of losing for ever, through submitting to the intellectual academic kind of learning, the capacity for this other kind of total concentration, the kind which both envelops the whole body, and at the same time can be spread out in spiritual envelopment of the object. And without this other kind I felt one would indeed be a parrot, saying only what one had been taught to say.

The idea of a concentration which includes the whole of oneself as well as the whole of the object raised another question. How exactly does the capacity to make a whole picture in which every part is related connect with the capacity to be a whole person? Is the striving for one perhaps partly based on the striving for the other? And when, with infinite labour, such unity is achieved in a picture do we recognise it at once as something of unique value because it expresses one of the most fundamental urges of the force by which we are lived, the urge to form, to wholeness of pattern within ourselves? When we look at such a picture do we get a temporary glimpse of what it would be like to be a truly whole person? Also was my difficulty in understanding all that rhythm means in painting due in part to the fact that it is so closely linked with the essential nature of this force by which one is lived, this force that one can be so fearful of giving in to? Since rhythm itself consists of a two-ness, a continuing relation between two differences, either in space or in time, does it perhaps not represent the

most important fact about the way the pattern making force inside works, in active relation to the environment, to achieve a wholeness of the organism? At least it can work towards such a wholeness; but it all depends on whether the arrogant will gives up its omnipotence and devotes itself to providing the conditions under which the natural rhythms can grow; rather than trying to impose artificial ones, as I had done in my first attempts at deliberate picture making.

I now remembered Goethe's idea of colour as something which happens when white light and darkness meet; although not true of the physicist's world, it looked as though it might be true metaphorically of the world of psychic experience. For here was the fact to be faced that there was a startling change in the quality of experience itself when imagination was brought down to earth and made incarnate in the body, a sudden richness that was like the sun coming out over a world that had been all greyness. And not only did the weather change in one's soul when imagination was made incarnate and took its flesh upon it, but the very way one moved was affected. In drawing it was apparent at once in the quality of the line. Without such an incarnation one seemed to move as by the commands of an internal drill master, with it one could achieve the state of wholeness in which:

'It doth not by another engine work,
But by itself; which in the act doth lurk.'

PART IV

THE USE OF THE FREE DRAWINGS
(The Image as Mediator)

'Life is an art. Life with its creating power, depending for man on the self-yielding of activity and thought, is an endless interplay. And at this moment when we are urged so constantly to look at facts, the objective situation, the concrete circumstance, the actual event, it is especially necessary that we learn how to connect the perceptual planes, how to let every fact contribute to those principles which by use again in the factual world become again transformed, and thus man grows always through his activity.'

<div align="right">Follett, p. 141</div>

THE ROLE OF THE MEDIUM

'*I saw a peacock with a fiery tail*
I saw a blazing comet drop down hail
I saw a cloud wrappèd with ivy round
I saw an oak creep on along the ground
I saw a pismire swallow up a whale
I saw the sea brimful of ale
I saw a Venice glass five fathom deep
I saw a well full of men's tears that weep
I saw red eyes all of a flaming fire
I saw a house bigger than the moon and higher
I saw the sun at twelve o'clock at night
I saw the man that saw this wondrous sight.'

Anon.

'*Deare love, for nothing less than thee*
Would I have broke this happy dreame,
It was a theame,
For reason much too strong for phantasie
Therefore thou wakd'st me wisely: yet
My Dreame thou brok'st not, but continued'st it,
Thou art so true, that thoughts of thee suffice,
To make dreames truths; and fables histories;
Enter these armes, for since thou thoughtst it best,
Not to dreame all my dreame, let's act the rest.'

John Donne

A FURTHER aspect of this problem of establishing a dialogue relation between two differences, as illustrated by the method of the free drawings, was to do with the extreme pliability of the material, of chalk, charcoal, paint. I thought of this aspect of the matter when considering a painter's definition of painting as being 'the expression of certain relationships between the painter and the outside world'.* For I felt a need to change the word 'expression' of certain relationships into 'experiencing' certain relationships; this was because of the fact that in those drawings which had been at all satisfying there had been this experiencing of a dialogue relationship between thought and

* Juan Gris.

the bit of the external world represented by the marks made on the paper. Thus the phrase 'expression of' suggested too much that the feeling to be expressed was there beforehand, rather than an experience developing as one made the drawing. And this re-wording of the definition pointed to a fact that psycho-analysis and the content of the drawings had forced me to face: the fact that the relationship of oneself to the external world is basically and originally a relationship of one person to another, even though it does eventually become differentiated into relations to living beings and relations to things, inanimate nature. In other words, in the beginning one's mother is, literally, the whole world. Of course the idea of the first relationship to the outside world being felt as a relationship to persons, or parts of persons, was one I had frequently met with in discussions of childhood and savage animism. But the possibility that the adult painter could be basically, even though unconsciously, concerned with an animistically conceived world, was something I had hardly dared let myself face.

Looked at in these terms the problem of the relation between the painter and his world then became basically a problem of one's own need and the needs of the 'other', a problem of reciprocity between 'you' and 'me'; with 'you' and 'me' meaning originally mother and child. But if this was the earth from which the foundations for true dialogue relations with the outside world should spring, did they always get established there? It looked as if they did not, at least certainly not over the whole field of experience. It looked as if for many people they only became established partially, that there were always certain areas of psychic country in which they had failed; and what was established instead, as always when dialogue relationship fails, was dictatorship, the dominance of one side or the other. It seemed that in those areas in which one had lost hope of making any real contact with the outside world one of three things could happen. First one could try to deny the external demand and become an active, dictatorial egoist, actively denying the need of the other, trying to make one's own wishes alone determine what happened. Secondly one could become a passive egoist, retreating from public reality altogether and taking refuge in a world of unexpressed dreams, becoming remote and inaccessible. Thirdly, one could allow the outside world to become dictator, one could fit in to external reality and its demands, but fit in all too well, the placating of external reality could become one's main preoccupation, doing what other people wanted could become the centre of life, one could become seduced by objectivity into com-

plete betrayal of one's own side of the matter. Seduced by objectivity seemed the right phrase; for I remembered how, when the scribbled free drawing did not begin to look like a recognisable object soon enough and I would deliberately force it into something recognisable, then the drawing had an unpleasant quality for which the word 'meretricious' came to mind.

The results of such a seduction were, it seemed to me, shown by the content of such drawings as the heath fire and the blasted beeches; for these surely offered an example of the possible discrepancy between what one could imagine one was feeling about the object looked at and what one really felt. Thus it certainly did look as though one could sacrifice too much to apparent sanity, to seeing only the public reality of the external world, the objective aspect that is conventionally agreed upon. And having so denied the private one it could become or remain proportionately distorted, so that one's dreams could be not at all what one imagined them to be, the gap between the sky and earth, inner and outer, could become too big to be easily bridged.

This idea of being seduced by objectivity raised again the whole question of the actual ways in which one's relation to the outside world develops, from the moment of birth onwards. It suggested that such a dictatorship of the external could be set up in infancy, even with the best of intentions on the part of the adults, simply by inability to give time for the wish to enter into relationship to come from the child's end; thus the establishing of reciprocity could fail simply because the child's time rhythms of need and wish are different from the adult's. Or not only could it fail from wrong timing, it could fail through inability to establish communication, since the child's small gestures of relationship are so easily over-looked or misunderstood. Of course this failure of relationship is inevitable at times, it is part of the agonising side of being a child; but here came in the particular aspect of the free drawing method that apparently made it partly able to compensate for that failure, able to act as a bridge between the public and the private worlds. For by it one could find an 'other', a public reality, that was very pliant and undemanding; pencil and chalk and paper provided a simplified situation in which the other gave of itself easily and immediately to take the form of the dream, it did not stridently insist on its own public nature, as I had found natural objects were inclined to do. So by means of this there could perhaps come about the correcting of the bias of a too docilely accepted public vision and a denied private one. And apparently it could come about

just because there was this experience of togetherness with one's medium lived through together. Because of this one could reclaim some of the lost land of one's experience, find in the medium, in its pliability yet irreducible otherness, the 'other' that had inevitably had to fail one at times in one's first efforts at realising togetherness. Granted that it was a very primitive togetherness, one that allowed the other only a very small amount of identity of its own, yet it did seem able to serve as the essential basis for a more mature form in which both other and self have an equal claim to the recognition of needs and individuality; just as psycho-analysis does through the analyst acting as a pliant medium, giving back the patient's own thought to him, in a clarified form, rather than intruding his own needs and ideas.

Such a formulation of the process also made clearer the Noah's Dove drawing in the series on the theme of 'Earth' (Fig. 10 b). Thus the extreme result of the lack of correspondence in time, between the experiencing of one's earliest needs and the satisfying of them by the adult concerned, would surely be this: it would be that the dreams of what one wanted might never become related to any reality of the external world at all, so there would be, so far as feeling was concerned, nothing but a waste of waters everywhere. The result of such an extreme discrepancy, in terms of character, would surely be a person

FIG. 47

who does not know what he wants because what he wants cannot be described in terms of anything that exists. If this lack of correspondence permeated one's whole life one would of course be mad and incapable of looking after oneself. But one might also be mad in parts, with this primary kind of madness, there might be certain aspects of one's experience which had never been properly hitched on to external reality; so one might at times become as a mariner sailing into a windless ocean and be temporarily unable to move in any direction whatever.

There was one drawing (Fig. 47) which had never been finished (all the others were made in one sitting). Its story was that somewhere in this desolate island there was a castaway whose boat had become so broken that he could not escape. The title was 'Ego-Island' and the broken boat seemed now to be the broken bridge to the external world. In fact, the drawing seemed to portray a state of mind which was perhaps close to that described by Traherne when he said:

> 'My piercing Eyes unto the Skies
> I lifted up to see;
> But no Delight my Appetite
> Would sate;
> Nor would that Region shew Felicity:
> My Fate
> Deny'd the same; Above the Sky,
> Yea all the Heav'n of Heav'ns, I lift mine Eye:
> But nothing more than empty Space
> Would there discover to my Soul its face.'

Now also it seemed possible to try to re-state these ideas about both the role of the free drawings, and of psycho-analysis, in terms of illusion. Could one say that by finding a bit of the outside world, whether in chalk or paper, or in one's analyst, that was willing temporarily to fit in with one's dreams, a moment of illusion was made possible, a moment in which inner and outer seemed to coincide? Was it also true to say that it was by these moments that one was able to re-establish the bridge, mend the broken boat, and so be re-awakened at least to the possibility of creative life in a real world? Was it not a legitimate hypothesis to suppose that by these moments of achieved fusion between inner and outer one was at least restored potentially to a life of action, a life in which one could seek to rebuild, restore, re-create what one loved, in actual achievement? So one could turn one's fables (which were originally histories, but seen subjectively)

once more into histories, into real experience in a real world. And this was made possible, both in a small way in free drawing, but more fully in psycho-analysis, because in both the situation has well-defined limits, in neither is one committed to the repercussions that action in the real world brings. In drawing one can draw anything one likes, because it is only a drawing and the paper can be torn up. In psycho-analysis one can say anything one likes, because it is only saying and the analyst has been trained not to react as he might in real life; in fact it is just because he has made a bargain that he will not 'act the rest' and yet is a real person that he can therefore serve as the bridge which makes 'dreames truths and fables histories'.

But if this were right and I really had succeeded in discovering a primitive reciprocity through the use of the medium, in the free drawings method, I did not want to stop there; I wanted to go on and learn how to bring an 'other' that had a less pliable nature than chalk and paper into the relationship. I wanted to learn how to create, by painting, a true reciprocal relationship between dreams and what was outside; in fact to learn how to endow the objects of the external world with a spiritual life, 'action', that was appropriate to their nature. It was not enough to treat the external object merely as a peg on which to hang quite fortuitous private fancies, I wanted what I imagined about it to fit in with the object's essential nature. I wanted to ensoul nature with what was really there, to make perception of the hidden insides and essential nature of objects fit in with what I knew, in moments of keenest awareness, to be really there. I wanted painting to be both a means towards and a record of true imaginative perception of significance. And to do this it was necessary to select those details of appearances which emphasised the nature of the 'soul' of what I was looking at, a 'soul' which was both really there, but which also was something that I had given to it from my own memory and feeling, since otherwise I would not have been able to see what was really there.

Certainly the experience of making the free drawings could be looked upon as a stage towards this. Undoubtedly they had achieved the clothing of certain dreams with recognisable qualities of shape and colour so that they could now be given 'a local habitation and a name'. After this they would never be quite the same again, both the gods and the demons were being brought down to earth, their power more ready to be harnessed to real problems of living, madness was becoming more domesticated and tamed to do real work in a real world.

Instead of remaining abstracted and bewitched by an inner vision that had only a very remote and distorted relation to the external world, one could bring 'the man that saw this wondrous sight' down to earth and action. Also, by achieving a concretisation of dreams, a permanent recording of the transfigurations, there was the possibility that other people could share them. And by the fact of other people being able to share, vicariously, the moment when one's gods had descended, one then gained a firmer hold on the spiritual reality of one's gods—or one's devils. So one came to know more clearly what one loved and would want to cherish in living and what one hated and would seek to eliminate or destroy; and by this one's life developed a clearer pattern and coherence and shape and was less a blind drifting with the tides of circumstance.

THE ROLE OF IMAGES

'*My non-intelligence of human words*
Ten thousand pleasures unto me affords;
. . . .
Then did I dwell within a world of light,
Distinct and separate from all men's sight,
Where I did feel strange thoughts, and such things see
That were, or seemed, only revealed to me,
There I saw all the world enjoyed by one;
There I was in the world myself alone:
. . . .
 No ear
But eyes themselves were all the hearers there,
And every stone, and every star a tongue,
And every gale of wind a curious song.
. . . .
 But when I
Had gained a tongue, their power began to die.'
. . . .

<div align="right">Thomas Traherne</div>

'Thus concepts are not formulated, but formulating, experience. Those who hurl diatribes against the conceptual simply do not understand its place. Concept making is a long, slow process. It is all life working ceaselessly on itself, building itself up. Bergson describes as a mere abstraction this self-initiated, living activity of concept building. When we are told of the dangers of the conceptual, the only warning we need take from that is that we must never allow the conceptual complex to be separated from the concrete field of activity, we must always understand what thought is perceptually.'

<div align="right">Follett, p. 144</div>

NOW ANOTHER question had to be answered about the free drawings. For the fact that the ideas in them were obviously in part determined by the circumstance of a Freudian analysis did not, I thought, alter another fact; that was that they embodied a form of knowing that traditional education of the academic kind largely ignores, and one that I myself was unaware of using—until I began to study the drawings in detail. But when I had done this there had been no doubt that many of the drawings did represent thinking of

some sort, reflections about the human situation, as well as experiences with a medium. So the question arose, why had it not been possible to think out such ideas directly in words? This raised the more general question of thinking in the private language of one's own subjective images, as against thinking in the public language of words. It also brought to the fore the problem of the academic and over-linguistic bias of traditional education.

In order to achieve more understanding of this matter it was necessary to try to compare the relative advantages of thinking in words used logically versus thinking in non-logical imagery, whether in words used poetically or in quite non-verbal imagery such as in the free drawings.

The first advantage of the thinking in pictures was that it was apparently much quicker; many of the drawings which had taken me so many years to translate into logical terms had been made in ten or twenty minutes. The second advantage was that the statements in pictures were much more comprehensive than verbal statements, meanings that stretched back through the whole of one's experience could be presented to a single glance of the eye. And not only did they bring so much of the past into a single moment of present experience, they also embraced a wider range of bodily experience than intellectual verbal statements can; by stimulating the sense of rhythm, balance, colour, movement, they seemed to give the sense of a solider, deeper-rooted kind of knowing than any purely logical statement ever did. And when, in fact, I had succeeded in backing up by logical analysis and reason the knowledge that had at first been obtained in this pictorial way of thinking, I then felt I had a much firmer hold upon it; knowledge not so rooted in a private store of images seemed to have an impermanent and unsubstantial quality, however much supported by rational argument.

All this might be summed up by saying that the drawings were intuitive rather than logical reflections about living, they were attempts to express the wholeness of certain attitudes and experiences which logic and science, by their very nature, can never do; since logic is bound to abstract from whole experience and eliminate the totality of the particular and the personal.

Some of the disadvantages of thinking in this way followed from the advantages. The statements about living contained in the drawings were certainly very private ones; they could not, as long as they were just drawings, be argued about and proved right or wrong. Only

when they were translated into intellectual statements, as has been attempted in this book, could other people argue about them and agree or disagree. As long as they were presented only in visual imagery, no one could even know for certain that that was what I had meant; although other people could add meanings of their own to the drawings no one could prove that I had not had the ideas about the drawings that emerged in their stories. And neither could I prove that I had not attached the meanings to the drawings quite arbitrarily in order to establish a preconceived case. I might have wanted to prove something I had already thought out and used the drawings to bolster up my ideas; the whole thing might have been a put-up job, wittingly or unwittingly. Such objections, however, surely applied to all intuitively reached judgements and was one of the reasons why science and logic had ever been developed at all.

In the light of the dilemma of the Angry Parrot, I could now see something more of what the over-academic kind of education might be leaving out. It seemed to me that its defect was not only that it was so cut off from ordinary living; thus it was not enough to try to alter it only by more active contacts with 'real' life, as distinct from book-learning. It was also that there was too little recognition of the essential role of the bridge between lived experience and logical thought: that is, the role of the intuitive image. There was not enough recognition of the danger of that too early or too docile acceptance of the particular public reality that an intellectual statement is; the danger portrayed, for instance, in the Dodder-Clown drawing, with its mockery covering the fear of intellect that is cut off from the raw facts of lived experience.

As for the effects of the gap in orthodox education, through its failure to make sufficient allowance for the spontaneous image, it seemed possible that the growing demand for psycho-analysis might be in part one of the results. Thus the psycho-analyst has to undo the bias; by attending to the patient's own intuitive reflections and making him attend to them himself, through looking at dreams and day-dreams and undirected thinking (what at school is called 'inattention', 'wandering thoughts') the analyst in fact helps him to learn how to think, how to discover the proper balance between intuition and logic.

When one tried to compare the two, intellect and intuition, it was so clear that one did need both, the one reaching out to the whole of experience, ranging to the limits of the 'wild surmise', the other testing and sifting and organising the knowledge so obtained. But the diffi-

culty was to allow these two differences to interact freely. In other words, here was another ineradicable conflict to be continually accepted as part of living, that between, on the one hand, desire for the wholeness of experience, and on the other the necessity to analyse and break it up into bits for the sake of communicability and the growth of further wholes. And it looked as if the conflict might be increased by anxieties to do with wholes and bits. Thus it might be possible to come to over-value the intuitive approach and shrink from the effort of logical analysis because this analysis was too much associated with unadmitted destructive wishes and hostility. I had so often felt, when a thought was first experienced in terms of a glimpsed visual picture, that to try to turn it into words would be to lose something irreparably, that its wholeness and splendour would be for ever destroyed. It seemed now that I had been right in supposing that something would be lost, wrong in assuming that it would be forever, wrong in not realising that the acceptance of division, analysis, bits, acceptance of the partialness which was inevitable in logical communication, was necessary for the growth of new wholes.

The difference between the logical way of looking at the world and the other way seemed particularly illustrated by the difference between a statement in prose as compared with one in poetry. In poetry it seemed that there was not only a joining up of oneself and what one looked at, there was also a joining up of feeling and knowing. For instance:

> ' ... there they hoist us,
> To cry to the sea that roar'd to us, to sigh
> To the winds, whose pity, sighing back again,
> Did us but loving wrong.'

I found it was impossible to say this to oneself and remain a detached observer, as one could with the prose statement about castaways set adrift in an empty sea. For in saying it one felt actually there oneself, the bodily sensations of the castaways became one's own. And this seemed because of the way the consonants and vowels fitted into the rhythm of the words; for instance, in the phrase 'cry to the sea' the 't' of 'to' cut short the thin high-pitched 'y' of 'cry' and one had the sensation of the wind whisking the cry from one's very lips and drowning its small sound in the deep echoing vowels of 'roar'. And just because of this, the feeling self and the body self, which had had to be separated from the knowing self in the detached prose description,

were here joined up again, one was feeling what one knew. The poet, just because he was a poet, had had the art to bring bodily sensation into the experience of thinking about castaways, he had known how to play directly upon the rhythm of one's breathing in speaking the words, how to use the lowness and highness and sensory texture of the vowels and consonants to convey his meaning. He had not been content with choosing his words according to their dictionary definitions and logical grammatical arrangements, but had chosen them and arranged them for their qualities in the ear and on the tongue and between the lips.

Having come, through the study of the free drawings, to make a comparison between intuitive and logical ways of thinking, I now found I had worked through to some sort of intellectual formulation of what to believe in in living, not a finished statement but a marking out of the directions of belief. And it was not science, I could not make science a religion, since science can never apprehend the wholeness of experience; and it was not art, at least certainly not art for art's sake, since art and living are two different things. But it was to go on finding out about (by science) and experiencing (both in art and living) the rhythm between the two opposing ways of relating oneself to the other; the rhythm between the way of detachment, of analysis, of standing apart and acting according to a preconceived purpose; and the way of fusion, becoming one with what is seen, steeping oneself in it in a spontaneous acting together. It seemed to me that science and logic knew a lot about the first phase of the rhythm, the detached way of looking at life in which self and other are separate. But the second half was much less understood, because, in order to study it at first hand science had first to experience it, and that meant science denying itself and taking the plunge into a different way of being.

PART V

THE USE OF PAINTING

'The full acceptance of process gets us further and further away from the old controversies. The thought I have been trying to indicate is neither conventional idealism nor realism. It is neither mechanism nor vitalism: we see mechanism as true within its own barriers; we see the *élan vital* (still a thing-in-itself) as a somewhat crude foreshadowing of a profound truth.'

Follett, p. 90

'In the arts, especially in painting, the swing of the pendulum between "subjectivity" and "objectivity" is most interestingly apparent. In psychology we have the introspectionists and the behaviourists.

'I do not see how such opposing tendencies can be avoided while we see reality either in subject or in object; I do not see how we can run fast enough from one to the other to keep ourselves within the region of truth. But our latest psychology is taking us a step beyond this and putting itself in line with the oldest philosophy. Holt, more clearly perhaps than any other recent writer, has shown us that reality is in the relating, in the activity-between. He shows us how in the "behaviour-process" subject and object are equally important and that reality is in the relating of these, is in the endless evolving of these relatings. This has been the grain of gold of the profoundest thinkers from Aristotle to the present day. Of course the subject is no more a mere reflex arc than it is an evangelical soul; nor are subject and object "products" of a vital force. For a century, roughly speaking, objective idealism has given us—its innermost truth—existence as unitary experience which upon analysis resolves itself into the two generic differings which have been called subject and object. Now physiologists and psychologists in their treatment of response are approaching this view.'

Follett, pp. 54, 55

PAINTING AND LIVING

I HAVE tried to show how this study of the free drawings had led me to think about a particular kind of new experience, one which resulted from the interplay of the two fundamental differences. The two partners in the interplay could be given various names, such as:

> imagination and action
> dream and reality
> incorporated environment and external environment.

But whatever the name, they always seemed to refer to two sets of happenings which certainly have to be distinguished if one is to go on living; since there is all the difference in the world, for instance, between thinking about having a meal and actually having one.

Of course this idea of the two fundamental differences was not something I had only just begun to think about. I had once even succeeded in answering examination questions on the history of philosophy; I had had to start with Descartes and learn how he made the distinction between mind and matter, and how this became the foundation of modern scientific achievement. But now I had not only found, after years of uncomfortable experience, that it was an urgent task to bring these two together again; I had also found that the making of the distinction was not only an intellectual achievement, it was also an emotional one, having a long history of accepted disillusion behind it.

Now also I had found a new way of thinking about the distinction, at least, new to me. It was in terms of the difference between the external environment and the incorporated one. And this way of describing it did now serve to emphasise certain specific aspects of the difference; for instance, that of changeability. Thus some of the drawings had seemed to show that, unlike the external environment, the incorporated one did actually change according to one's feelings, and particularly in response to one's unadmitted feelings. If one had been full of unadmitted hate it could apparently become a desert land with only dead bones in it, since the destructive wishes could be felt as fulfilled merely by thinking them. And I had had to realise also, through

the drawings, how close love and hate are bound to be; and that since
to hate what one loves is probably the most mentally painful of all
human experiences, it is very hard not to deny the hating and pretend
to oneself that it does not exist. But I had had to realise too that the
denied hate can then work itself out internally, making one feel, in
extreme conditions, that one's inner world is wrecked and everything
is hopeless; even though the external environment, objectively seen,
may be full of promise.

There were further aspects of the difference between the inner world
and the outer one, brought to the fore by the drawings. Sometimes
the inner is described as a reflection of the outer; but surely it was a
very active and headstrong kind of reflection, it could apparently
elaborate on its external prototype as freely as Alice's 'Through the
Looking Glass' world did. Thus it seemed that, although it owed its
basic pattern and shape to the original external environment, yet every
kind of modification could happen to it once it was incorporated and
in the process of incorporation. Moreover it was surely different from
the objectively seen environment even in the moment of incorporation,
since what we take in to the stuff of our psyche is obviously a relation-
ship; it is not the objectively seen public facts of our lives, as they
appear to detached observers, that become part of us, it is the way
things seem to us at the moment they happen that is taken in, at the
moment when we are actively and emotionally involved in them.
And once stored inside us, these memory traces of what were origin-
ally actual experiences of relationship, bits of life already lived, could
become, amongst other things, types, they could lose their accidental
qualities and keep their common essences. For instance, the good ones
could become more good and the bad ones more bad; as illustrated by
the innocent and wicked creatures in the drawings. In fact, apparently
every kind of re-sorting could go on, and produce a whole inner
universe, including an Olympus and an Underworld. Of course, such
a relative independence in the internal world did not mean that there
was not, at least in psychic health, a continual interchange between the
two, just as in Greek mythology the gods continually get themselves
mixed up in human affairs. It did not mean that one's internal weather
could not spread sunlight or gloom over the outer contacts, or con-
versely, that good fortune or disaster externally could not also bring a
change in the inner landscape. But at the same time a certain inde-
pendence of the external world persisted, otherwise we would surely
not be able to endure great reverses of our external fortune without

a corresponding wrecking of our inner stability. Thus the discrepancy between the two was biologically necessary if one was to have any capacity to rise above one's circumstance and be more than the blind slave of accident. All the same, when one first experienced the discrepancy one certainly did not know it was a biological advance, it could feel more like a matter for burning fury of despair. So behind the bare fact of the discrepancy there could lurk a tremendous potentiality of primitive hate, the feeling accompaniment of the disillusion inherent in the human situation.

Of course I had known intellectually that this was one of the main tenets of psycho-analytic theory; but I certainly had not really believed it, I think it had seemed a too hopeless picture of human existence. And what I had not known, until the study of the method of the free drawings had forced me to see it, was that this hate that is inherent in the fact that we do have to make the distinction between subject and object, if we are to develop at all beyond blind instinct, is overcome in a particular way through the arts. It is surely through the arts that we deliberately restore the split and bring subject and object together into a particular kind of new unity. What I had not seen clearly before was that in the arts, although a bit of the outside world is altered, distorted from its 'natural' shape, to fit the inner experience, it is still a bit of the outside world, it is still paint or stone or spoken or written words or movements of bodies or sounds of instruments. It is still a bit of the outside world, but the difference is that work has been done, there has been a labour to make it nearer one's inner conception, not in the way of the practical work of the world, but in an 'as if' way. Thus it seemed that the experience of outer and inner coinciding, which we blindly undergo when we fall in love, is consciously brought about in the arts, through the conscious acceptance of the as-if-ness of the experience and the conscious manipulation of a malleable material. So surely it comes about that in the experience which we call the aesthetic one the cause of the primary hate is temporarily transcended. But not only is it temporarily transcended, surely also it is permanently lessened. For in the satisfying experience of embodying the illusion there has in fact been an interchange. Since the object is thereafter endowed with a bit of the 'me', one can no longer see it in quite the same way as before; and since the 'me', the inner experience, has become enriched with a bit more of external reality, there is now a closer relation between wishes and what can really exist and so less cause for hate, less despair of ever finding

anything that satisfies. In fact the aesthetic experience has modified the wish, moulded a bit of oneself into a new form by giving it a new object; and at the same time it has given a previously indifferent bit of the outside world a new emotional significance.

Such a view of art threw light on a question I had long puzzled about, the difference between painters in their attitude to realism in painting. There were obviously great differences in whether they were more concerned with landscapes of the inner world or the outer; or rather, differences in the amount of contribution from public or private reality in what interested them, and hence differences in the amount of remoteness or distortion in their painting. I remembered hearing that one painter had said 'One distorts in order to love' and now I could see what he meant; for one might have to alter very extensively the appearance of the peg to make it carry one's earliest and yet perhaps most vital dreams.

The study of the free drawings had also shown that there was yet another form of the basic contradiction to be taken into account. It was connected with the specific role of art as self-expression and the fact that the inner subjective and outer objective aspects of reality are in a continual state of change and development. Thus there is not only a permanent gap between the perfection we have it in us to conceive of and the actuality of what can really happen, there is also a gap between the inner reality of feeling and the available ways of communicating what we feel. It is obviously a discrepancy that varies in degrees in different people and in different phases of society; it is a gap that is bigger wherever the conditions of our living are changing rapidly so that the old forms for describing our feeling experiences become no longer adequate. Thus art is not only a created fusion between what is and what might be; it is also a created way of giving the inner subjective reality of feeling an outer form, in order that it may be shared, and so also tested and verified; it is a making of new bottles for the continually distilled new wine of developing experience.

This view of the artist's task led on to still another aspect of the creative synthesis between subject and object. It was to do, not so much with the problem of what one seeks to find in the external world, but with what one seeks to give. Here I found Blake's way of putting it useful. When two people meet in relationship the Prolific (to use Blake's terms) in one cannot give unless the Devourer in the other is ready to receive; and the Devourer in one cannot receive unless the Prolific is willing to give at the moment his products are

required and what is required. So here was the problem, not only of endowing the outside world with one's own dream and so giving it desirability, coming to believe that what it offers is what one wants, but also the reverse problem of coming to believe that the outside world wants what one has to give. Obviously this belief can be very precariously established; and it is impeded, not only by inner doubts about one's wish to give, doubts of the strength of one's love and constructive wishes as compared with one's hate and envy and greed, but also by actual failures of one's surroundings to need what one has to give. One could think of it in terms of social life and finding one's niche in the world; but also in more personal terms, the difficulty of bringing the dream person one would like to give to, the ideal receiver of one's gifts, down to the earth of the actual persons around one and their actual needs. Everyone's task in the transition from childhood to adulthood clearly centres round this problem of finding a particular niche in the social world, of finding the gap or need in the social structure into which one can pour one's energies and find that they are wanted. I supposed that those who can find a ready-made gap have an easier task, but many have to make their own, and some can neither find one nor create one. But perhaps in painting one does create one's own gap by deciding on the frame, both literally and metaphorically; for one can make the size of the gap, the frame that has to be filled, to suit oneself; and one must also choose what shall fill it. Whether one will find a wider gap or need to be filled, in the sense of finding one's public and fulfilling a social as well as an individual function in one's painting depends on many circumstances. I supposed that the well-adjusted person who is not an artist is one for whom real life has succeeded in providing and he in coming to recognise and believe in two things: both real external producers of what he needs and real external devourers of what he has to give. But the painter as painter has tried to solve the problem on another plane than that of external reality, he has invented a half-way house between the dream receiver and the external one; a half-way house that is more pliable and under his own control than the external world, but also more fixed and stable than the merely internal dream receiver of his love.'

There were also other questions to be considered, to do with the relation of art as an activity to ordinary life activities. It seemed to me that the non-artist in each of us, the common sense practical man in us, has relinquished a great part of his early illusions. He has accepted the conventional view of external or shared reality more or less with a

good grace and prosaicness, he has been practical and renounced both the high ecstasies and the terrors of his illusion, for the sake of solid realities of living—except when he is in love. But the renunciation may be at a higher cost than he realises, since he may pay for what he gets in the denying or killing off of part of his psychic potentialities. On the other hand the artist in us surely deals with the basic conflict in a different way, since he seems to have an unyielding determination neither to deny his dream nor the claims of external reality. He does not, as the neurotic in us does, try to deny the conflict altogether and get himself in a great muddle by unwittingly treating bits of the external world as if they were part of his dream. He recognises and accepts the difference, at least as far as his practice is concerned, even if he does not consciously say that that is what he is doing, even if he consciously claims to be an idealist philosopher and tries to deny the objective existence of the external world. In his practice he recognises the real objective qualities of his medium, but he manipulates these to suit his inner conception. Thus he does not try to deny or forget about illusion, instead, he seeks to affirm it and take responsibility for it, even in its most primitive aspects.

But the artist in us also has to pay and perhaps with an opposite currency from the practical man, for he has to give up working for the direct pleasures that the practical man enjoys. And he also has to pay in another way, directly to the demands of that external reality which is society. He has to accept some public artistic convention, such as the outline or the musical scale or the grammar and vocabulary of a particular language, something that his particular time and place in history make available for him to use in conveying his private idea. Of course he may contribute to this convention himself, enrich and enlarge it, but he cannot start off without it, he cannot jump off from nothing. And perhaps he accepts this need to pay in communicability the more readily because, with others able to share his dream, he is more absolved from the guilt of defiance of common sense reality, absolved from the guilt of clinging on to 'the many splendoured thing' while others have felt obliged to give theirs up. And if it be true that the artist in us and the lover in us have refused to give up their 'intimations of immortality' it would suggest another reason for some of the public resistance to new forms of art; for when a person chooses to make the artist in himself the basis of his relation to society and becomes professionally 'an artist', then if he does not make his dreams comprehensible so that more than a small coterie can share them, then

he earns the fierce animosity of those who feel themselves shut out. I thought those who do not understand the artist's creations are liable to indulge in the righteous indignation of the child who feels he himself has been good and given up his earlier enjoyments, but sees another child who has been less docile and obedient and yet is getting away with it.

Such ideas about what one might be trying to do in one's painting pointed the way to settling certain very practical doubts I had had about the relation between painting and living. For years I had had to decide each week-end, should I shut myself away and paint or should I just live? It was perhaps less of a problem for the professional painter who could live in his spare time. But for the Sunday-painter it brought the need to balance up the various renunciations and gains. I had so often come away from a morning spent painting with a sense of futility, a sense of how much better it would have been to get on with something practical that really needed doing. And I had often felt, when out painting, both exalted and yet guilty, as if I were evading something that the people round me, all busy with their daily lives, were facing, that their material was real life and mine was dreams.

But was it?

There was one drawing which did seem to embody, through its associations, these very thoughts. Its title was from Francis Thompson:

> 'O dismay,
> I, a wingless mortal sporting
> With the tresses of the sun.'

It had been intended as an exercise in learning the correct proportions of the human figure, but it had turned out an abstract geometric design (Fig. 48). At first, I had thought the title showed fears that, like Prometheus and Icarus, one might meet with disaster from presuming too high. Also I had found a diary note on the same theme:

> 'If one paints in order to possess, make one's own, it's not only perhaps a greedy thing to do, but also a kind of stealing the fire of the gods, stealing immortality, eating the forbidden fruit of the tree of life which would make men as gods.'

Certainly it did seem to express the feeling that it was taking a risk not to rest content with the conventional view of reality and with the duties that were publicly recognised as such. Certainly also it expressed the thought that to try to re-make what one loved, in order to have it permanently there and under one's control, was an attempt to cheat

Fig. 48

mortality. Certainly the greatest disillusion, the greatest discrepancy between one's wish and the external facts, is the fact of death. Dreams can be made relatively immortal, in words and stone and paint, but people all grow old and die. But now I felt, even if it was cheating, stealing a march on death, I was prepared to accept that, take responsibility for it, since it no longer seemed, as in the Prometheus myth, like stealing a power to create which by right only belonged to the parents. And this surely was not the end of the matter anyway, it was not only cheating mortality; for in trying to re-make the object of one's love, symbolically, surely one was also re-making the desire for it, trying to turn the desire into something which did not destroy, by its possessiveness, the very thing one loved. And if this were true, then the doubt whether it was only dreams one was concerned with when trying to paint could be answered; for it suggested that the material in which the artist in us is trying to create is basically the raw stuff of human impulses. Through the process of giving life to the portrayal of one's subject, of coming to see it as a whole through the discovery of pattern and rhythm and so coming imaginatively to appreciate its nature, one is actually creating something, creating the spiritual reality of one's power to love it—if it is lovable; or laugh at it or hate it—if it is laughable or hateful. Ultimately then it is perhaps ourselves that the artist in us is trying to create; and if ourselves, then also the world, because one's view of the one interpenetrates with one's view of the other.

PAINTING AS MAKING REAL

THE PROSE quotations given here as chapter headings are from a book published in the United States in 1930. The book is concerned with the implications of scientific studies of creative experience between people and groups of people, whether in industrial, social or political relationships. I have quoted extensively from it because such formulations did seem to provide most cogent intellectual statements of some of the very problems that I was struggling with in private feeling and action. But there was one fact the implications of which I could not easily ignore. It was the fact that I had first read the book many years before making this study, even though, when choosing these chapter headings, it had seemed that I was reading them for the first time. So the question arose, why had it been necessary to wait for the experience of the free drawings before becoming able to make Follett's ideas part of daily living? Now I thought the answer was indicated in certain passages of Follett's which seemed to leave out the one fact which in my own experience had turned out to be crucial.

> 'We do not wish to put up with strife for the sake of the peace that follows. Existence should not be an alternation of peace and strife. We should see life as manifold differings inevitably confronting each other, and we should understand that there is no peace for us except *within* this process. There is no moment when life, the facing of differings, stops for us to enjoy peace in the sense of a cessation of difference. We can learn the nature of peace only through an understanding of the true nature of conflict. It seems to me unfortunate that we are seeking something which does not exist. Only when we are willing to accept life as it is can we learn how to deal with it. To battle for a preconceived right involves the same error as to work for a pre-existing end, for it leaves out of question the never-ceasing movement of life which is always revealing to us new "rights" and new "ends".'
>
> (p. 262)

'We are seeking something which does not exist,' says Follett, and also that we are not willing to face life as it is. But why? Should we not also ask why we do this, not only deplore the fact that we do it?

The answer surely is that we are seeking something that does not exist as an objective reality just because it does exist as a subjective one. Thus there *are* moments when 'life, the facing of difference, stops for us to enjoy peace in the sense of a cessation of difference'. There *are* moments when subject and object do seem to become one. And the mistake we make surely is not in believing that such moments exist, but in not realising their subjective quality, in not recognising them as illusions, even though vital illusions.

There was also the following statement:

> 'In considering the phrase "resistance of the environment", it is patent that the whole philosophy of the person who tells us of resistance of environment is different from that of those who dislike the term. The latter believe that we are at home in our world, that we have not just happened on a cosmos that is alien to us, that we have not come where we do not belong. There seems to me a presumption that there is a fundamentally blessed relation between self and circumstance. It is the philosophy back of the resistance of the environment notion that I do not agree with. Resistance implies the opposition of nature, suggests: "I am but a pilgrim here, Heaven is my home", gives you a pretty forlorn idea of a self that has strayed out of its orbit. The philosophy involved in "progressive integration" gives us a soul at home and it gives the crescent self; it shows us that our greatest spiritual nourishment comes not from "inviting our soul", but in meeting the circumstance. There is only one way by which the spirit mounts, by that meeting which is the sacrament of life and needs no symbol because the self lives daily that sacrament from which it draws its sustenance.'

(pp. 131, 132)

Since such a philosophy explicitly maintained that we are born at home in the world, it implicitly denied the possibility that being at home in the world is something that we have to achieve. So also it ignored the possibility that we do only achieve it by a willingness of someone in our original environment of persons, in the actual home of our infancy, to fit in with our dreams. It ignored our original utter dependence on someone who would temper the implacable otherness of externality to fit our needs, temper it for us until such time as the external did come to grow happily significant.

Follett's book gave so much richness of thought that it seemed churlish to ask for more. Yet it did seem here to assume a reasonableness in people that could not so easily be taken for granted. It did not take into account how the poet and artist in us, by their unreason, by their seeing as a unity things which in objective reality are not the

same, by their basic capacity for seeing the world in terms of metaphor, do in fact create the world for the scientist in us to be curious about and seek to understand. In fact it did not deal with that function of the creative arts by which they provide a half-way house to external reality, that function by which they carry on, throughout our lives, the role that in our infancy had to be filled by a person, their function in providing a perpetual well for the renewal and expansion of our psychic powers.

My own experience, not only with the free drawings but in earlier experiments, had certainly shown how essential for anything but blind living was the emotionally coloured image, as well as the intellectual concept. Thus it was not until I had given up looking for direct help, either from intellectual concepts or factual observations of the external world, and concentrated first upon images, that I had begun to live at all, in any real sense. It was by following up all the apparently unconnected, but rich and sensuous and many-coloured images that the mind continually deposits on the shores of consciousness, like a sea upon its beaches; it was by studying 'what the eye likes' rather than what the reason affirms and verifies, that I had at last become able to use concepts to elucidate everyday experience and so become able to begin to live reflectively rather than blindly. Thus although Follett's statement might be justly considered to describe the goal of maturity, its ignoring of the nature and intensity of the struggle by which such maturity is achieved might lead to certain dangers. It might mean that those responsible for directing rational policies of reform, from whatever political angle, might unwittingly destroy conditions of life upon which the very roots of our sanity depend. In their enthusiasm for objectivity and hygiene they might advocate a so excessive diet of planned rationalism for the young that in fact would defeat its own ends; the result might be that deceptive lip-service to reality which only hides a deeper madness.

Having reached some idea of what function the arts might be fulfilling, it was now possible to see more what Cézanne might have meant when he said: 'Réaliser: tout est là!' Having seen how it could be that the artist, by embodying the experience of illusion, provides the essential basis for realising, making real, for feeling as well as for knowing, the external world, it was now possible to look further into the artist's role to see how it is that he adds to the generally accepted views of external reality; how in fact art creates nature, including human nature. Thus it seemed to follow that the artist is not only one

who refuses to deny his inner reality, but also and because of this, is potentially capable of seeing more of the external reality than other people, or at least, more of the particular bit he is interested in.

Looked at in this way, how inadequate the phrase 'Art for Art's sake' became; it was rather 'Art for life's sake'. So also it was now possible to pay more than lip-service to the statement that real life is always more full, richer, potentially, than the experience of any art; because I could now add that it is through art that we can come nearer to realising this fullness and richness. Thus the original doubt as to which was more real, the common sense world or the transfigured one, could now be answered: the transfigured world was the real one, potentially, because the mystery was then in the developing living facts evolving under one's own nose, not in some far away fairy-land. The mystery was that of the natural not the supernatural, for it held within it its future as well as its past, all its unrealised potentialities, all its 'becomingness', whether inside us or out.

Now also it became clearer how it was that the discovery of the method of the free drawings had made possible the acceptance of this fact. In all the years before happening upon the free drawing method I had had doubts about the relative value of a contemplative attitude to life as against an active one; for it had seemed that only in the contemplative state did the richness of the facts become apparent; as soon as active purposes appeared the facts seemed to lose their vital essence and become the mere instruments of those purposes. But now it was clear where the mistake had been, it lay in thinking of contemplation as essentially involving sitting still and action as being essentially purposive. What the method of the free drawings had embodied was something that could be called 'contemplative action'; and it was this, whenever achieved, which brought back the full sense of the significance of the facts as more than instruments of one's private purposes.

There was another result of this study. I could now begin to learn how to paint. At least I could take the risk of covering canvases and being dissatisfied with the result and going on to try again and even of getting professional help. And this seemed partly because I now knew more or less, or thought I did, what I was trying to do; it was also because having recognised the necessity of both illusion and disillusion, I no longer expected a painting to be a magical solution to every problem of life, and so no longer made the half-admitted demand that every picture should be a masterpiece or it was not worth doing.

As for the validity of the ideas about what I was doing when painting, whether they held for other people and in other times and places I did not know. Probably not. Perhaps some people could paint without needing to have any clear idea about what they were doing and some found quite different ideas. Probably the particular idea that served to spark the creative process could vary widely and depended upon one's own particular experience and moment of existence in history. Certainly it could not be an idea that was entirely uninfluenced by other people's ideas, since one does not live in a vacuum; but it did not entirely depend for its usefulness to oneself on other people's verification. The point surely was that one had to select and eliminate from all the variety of ideas about what the artist is doing, in order to fashion the idea that did in fact most effectively unify one's own particular approach to living. Thus I had certainly had to eliminate certain ideas absorbed from the intellectual climate of the epoch I had grown up in. And it was not only nineteenth century ideas about painting as pure representation that had had to be shed, it was also nineteenth century (and earlier) ideas about the efficacy of thought by itself, as an omnipotent God. Thus I saw now that the very first drawing I had done, after beginning to think about painting methods consciously at all, the one called 'The Mills of God' (Fig. 35) with its omnipotent Cleopatra's Needle had been a symbol of thought that believes itself a power apart from action. And although it was the job of psycho-analysis to show how such a belief can develop in the individual in infancy and be clung to in adult life, clearly there was a dead-weight of social ideology as well as personal need to be broken through before one could completely shed it. Thus it seemed to me that the study of the method of the free drawings had, in fact, led me to become aware of a struggle which was not only personal and not only to do with painting, it was essentially part of a contemporary struggle in the whole social world. It seemed to be in essence a struggle to slough off the old caterpillar skin of an outworn ideology about the relation of thinking to doing, of mind to body. Thus this study had led to the becoming aware of a revolution in man's attitude to his own thinking, a revolution that had been going on around me all the time, but which I had been failing to see the significance of.

Incidentally, I noticed now, and only now, a striking example of the split between inner and outer and the attempt to keep them artificially separated. I noticed the significance of the date when the free drawing 'Thunder over the Sea' (Fig. 9) had been made, with its great Indian

war drum looming in the sky. The date showed that it had been only a matter of days between the making of the drawing and the bursting of the storm of war over the whole of Europe. So the storm, which all this while I had been treating as a private and inner one, was not only that.

There was also another reason why it was now possible to paint. It was because there was one central fact that made it seem worth while going on, whatever the objective value of the pictures to other people. It was that I had discovered in painting a bit of experience that made all other usual occupations unimportant by comparison. It was the discovery that when painting something from nature there occurred, at least sometimes, a fusion into a never-before-known wholeness; not only were the object and oneself no longer felt to be separate, but neither were thought and sensation and feeling and action. All one's visual perceptions of colour, shape, texture, weight, as well as thought and memory, ideas about the object and action towards it, the movement of one's hand together with the feeling of delight in the 'thusness' of the thing, they all seemed fused into a wholeness of being which was different from anything else that had ever happened to me. It was different because thought was not drowned in feeling, they were somehow all there together. Moreover, when this state of concentration was really achieved one was no longer aware of oneself doing it, one no longer acted from a centre to an object as remote; in fact, something quite special happened to one's sense of self. And when the bit of painting was finished there was before one's eyes a permanent record of the experience, giving a constant sense of immense surprise at how it had ever happened: it did not seem something that oneself had done at all, certainly not the ordinary everyday self and way of being.

Having made such a discovery about a different way of being, the question arose, could not educational theory and practice somehow find out more about it and come to make more deliberate allowance for it; rather than concentrating so much on the way that stands apart and only tries to give an objective detached account of what it sees? In fact, I suspected that if education did manage to do this, one of the results would be not a lessening of the objective powers but a strengthening, once the needs of their opposite had been given recognition.* And not only this, was it not also possible that this different

* This is in fact happening. For instance, the way in which class teaching methods can be used so as to make allowance for this other way of being is vividly described in a book by a teacher of English: *The Education of the Poetic Spirit*, by M. L. Hourd.

kind of sense of self that grew out of creative concentration had bear-ings upon one's relation to the whole mass of other selves that one was in contact with? This sense of union achieved in attempts to create a work of art, this transcendence of separateness, might it not have its parallel in the union with other people that working together for a common purpose achieves? Thus the illusion of no-separateness between self and other, which is an illusion so far as bodily life was concerned, is not necessarily an illusion in the social sphere. Many years ago I had read somewhere, with a feeling of both incredulity and yet hope: 'The separate ego-entity is an illusion.' Obviously the separate body entity is not an illusion, and one undoubtedly has to establish and accept this basic fact before one can go any further; other-wise one has no solid ground on which to build one's sanity, one may allow oneself to believe one has the body of Helen of Troy and the brain of Einstein. But once that is established the demarcation of the boundaries of one's spiritual identity are not fixed, they do not have to remain identical with one's skin. Thus was it not possible that ortho-dox educational methods increased the hate resulting from the primary disillusion, not only by not giving enough scope for the aesthetic way of transcending that hate, but also by not giving enough scope for the social way: the way of spontaneous co-operation in enterprises under-taken together for the good of everybody who is taking part in them?

In short, could there not be an explicit recognition of the change in outlook that recognition of the nature of creative process brings? Could there not be a deliberate conscious concentration of attention on the change in educational techniques that are needed to embody such a belief? Surely what is convulsing the world to-day is such a growing recognition, which is having revolutionary effects in the outlook of every race and nation, whether they like it or not. For surely the idea is revolutionary that creativeness is not the result of an omnipotent fiat from above, but is something which comes from the free reciprocal interplay of differences that are confronting each other with equal rights to be different, equal rights to their own identity? But with such a growing belief there is also a growing recognition of how difficult it is for our human nature to allow for such an interplay, a recognition of what titanic emotional forces can be working against it.

I had certainly had to realise, through this study, what an amount more we need to know about the conditions under which this inter-play becomes possible. For in order to 'realise' other people, make them and their uniqueness fully real to oneself, one has in a sense to

put oneself into the other, one has temporarily to undo that separation
of self and other which one had so laboriously achieved. In one's own
imaginative muscles one feels the strain of the model's pose, in one's
own imaginative body one feels the identity of one's opponent, who
is one's co-creator. But to do this and yet maintain one's own integrity,
neither to go wholly over to the opponent's side, nor yet retreat into
armour-plated assertion of one's own view-point, that is the task
demanded. To be able to break down the barrier of space between self
and other, yet at the same time to be able to maintain it, this seems to
be the paradox of creativity.

Now also it became clear what was the meaning of one of the free
drawings which all this time had remained obscure. It was called
'Bursting Seed-pod' (Fig. 49) and it had obvious symbolic reference
to a personal theme of producing new life. But I had never felt satis-
fied with this explanation, it had given no sense that the drawing was
now fitted into its place in the whole series. But now it did fit in; for I
saw it as a picture both of the epoch I was living in and my own
relation to that epoch. I saw it as showing the irresistible thrust of life
that was giving birth to new ideas and also how these were bursting
through the seed-pod of the old world that gave them birth.

WHAT IT AMOUNTS TO

WHEN I look back over the course of this investigation it is now clear that the three separate streams of questioning and doubt from which it began have merged into one. They have, bit by bit, grown into an absorbing awareness of the need for practical enquiry into creative process.

The central certainty that this process does not work from purpose to deed, in the way that expedient activities do, is easy to put into words now, at the end, but was not there with effective conviction from the beginning. This means that the part of the book called Introduction is misleading. The habit of thinking in terms of purpose to deed was still so strong that when writing the introduction, after the book was nearly finished, I had almost believed that it was a true statement of how this investigation had begun. I had almost believed that it had in fact all started with a clearly thought-out purpose; I had almost believed that there had been a conscious decision that if it should be possible both to settle the vague questions stimulated by the emergence of the free drawings, and to find out how to paint, then it would also be possible to answer the question of what was being left out in traditional education. But now I can see that this is not true. There had been nothing in the beginning but vague uneasy feelings and an urge to follow certain trickles of curiosity wherever they might lead. All the same, I have left the introduction as it was originally written, partly because books need introductions, partly because the fact that it had seemed, retrospectively, that that was what I had set out to do from the beginning, was in itself an illustration of the later discovered truth that activity creates purpose.

Thus the book is not the retrospective account of a creative experience which had happened independently and was then written about, it is itself an attempted embodiment of the process of creating. And what had been created, not just by the activity of making the free drawings without preconceived purpose, but also by writing the book without fore-knowledge of where it would lead, was finally a new certainty of belief. And included in this belief was a realisation of the

total inadequacy of an earlier belief, previously unrecognised but doubly potent because of that, the belief that new things are produced by an omnipotent command from above, rather than by the free interplay of differences with equal rights to be different.

Also, having laboriously worked through to this view of creative process, not as a result of intellectual analysis but as something lived, it had now become possible to be aware of how the same idea is fertilising the general understanding of human affairs in many fields: not only internal affairs, between will and instincts, head and heart, standards and actuality, but also external ones, between managers and workers, teachers and taught, governments and governed.

And not only this; for I had also been unable to avoid the conclusion that this misconception about the nature of creative process, that I had been unwittingly acting upon, was the result of an urgent emotional need. It was the content of the free drawings that had made it clear, to me at least, that it is not through inadvertence that we cling to this misconception of the omnipotent fiat of creation, it is part of our immaturity. They had also made it clear that in order to grow out of such a misconception, in order to reach the maturity of being able to base all one's actions on the belief in interplay of differences, it was apparently necessary to be prepared for mental pain. For without a doubt this capacity to recognise and allow for the creative interplay of differences had a long and often stormy history; it was a position only won, if at all, after protracted battles with in-loveness, expectation, high hopes, and with feeling one's love betrayed, disillusion and despair, battles which had begun in the earliest years of our lives. For gradually I had come to recognise the fact that one could not know any baby well, if one was honest with oneself, without knowing also that these battles are first experienced, in all of us, if our experience has been normal, long before we have any words to tell of it or power to know that that is what is happening to us.

There was also one aspect of creative process that had turned out to be fundamental in this study, the aspect of perception of the external world. Observations of problems to do with painting had all led up to the idea that awareness of the external world is itself a creative process, an immensely complex creative interchange between what comes from inside and what comes from outside, a complex alternation of fusing and separating. But since the fusing stage is, to the intellectual mind, a stage of illusion, intoxication, transfiguration, it is one that is not so easily allowed for in an age and civilisation where matter-of-

factness, the keeping of oneself apart from what one looks at, has
become all-important. And this fact surely has wide implications for
education. For it surely means that education for a democracy, if it
is to foster that true sanity which is necessary in citizens of a demo-
cracy, foster the capacity to see the facts for oneself, rather than seeing
only what one is told to see, must also fully understand the stages by
which such objectivity is reached. In fact, it must understand sub-
jectivity otherwise the objectivity it aims at will be in danger of fatal
distortion.

FIG. 49

APPENDIX

I. THE ORDERING OF CHAOS

THE WRITING of this book turned out to be an attempt to discover, within the limits of a special field, something of the nature of the forces that bring order out of chaos. It was a study that had to do with the discovery of a different kind of integrative force than that which results from any attempt, of whatever nature, to copy a pre-existing ordered model. The question then arises, how is this different kind of integrating force to be talked about, whether in terms of scientific concepts in general, or in terms of those so far developed in the particular field of psycho-analysis. Also the question of the nature of the force or forces that produced the free drawings brought me to see that the other question, that with which this book began, of how psychic creativity works, had inevitably branched out into the second one; that is, how is this capacity called psychic creativeness itself to be conceived, in what terms is it to be talked about? While writing the book I had assumed that I knew what I meant by 'psychic creativeness' and had not troubled to define it; then I had gradually discovered that I did not know precisely. But finally, as a result of this study, and also as a result of writing a clinical paper on aspects of symbol formation, I had found a definition which seemed to be at least a workable tool: that is, that psychic creativeness is the capacity for making a symbol. Thus, creativeness in the arts is making a symbol for feeling and creativeness in science is making a symbol for knowing.

I want, in this chapter, to put forward the hypothesis that, from the point of view of psychic creativity at work, the logical terms in which the capacity for symbol formation is thought about are perhaps less important than the prelogical. I want to suggest that it is the terms in which we think, on the deeper non-verbal levels of the psyche, about this specifically human capacity for making symbols that in part determines the way the capacity works in us.

Thus the content of the free drawings seems to me to illustrate not only the anxieties associated with 'creative capacity', but also different ways of thinking about that capacity—and thinking about it in terms

that are derived from those various bodily functions which become the
centre of interest at different stages of infantile development.

II. The Anal Aspect of the Parrot's Egg

As the first edition of this book was planned more especially for the
lay public I deliberately did not enlarge upon certain aspects of the
material of the free drawings. At the time of writing it seemed possible
to describe the oral aspects of the problems depicted in the drawings
and to some extent the genital aspects; but the implications in terms of
the so-called anal phase of development were omitted. This aspect,
however, is obviously of great importance in any enquiry into ways of
thinking about the human capacity to make things, whether material
objects, or ideas, or both combined. It is clear that one cannot present
a book for analysts which deals with the theme of, on the one hand,
illusion, idealisation, falling in love (transfiguration), and on the other,
disillusion, falling out of love, denigration, without also talking about
the child's idealisation of and disillusion with what it gives as well as
what it receives.

Since writing this book I have had much clinical material, from both
adults and children, who were suffering from inhibition of the capacity
to produce ideas, whether in logical verbal form or in non-logical
artistic form. It was clear that these patients had an extremely idealised
notion of what their products ought to be, and the task of objective
evaluation of what they in fact produced appeared to be so disillusion-
ing to them that they often gave up the attempt to produce anything.
Attempts to interpret their difficulty led me to a consideration of the
whole problem of idealisation and the extent to which it is in fact
deluded. In so far as it applies to the human object it is obviously
deluded, since no real object can ever be 'what the whole soul desired'.
But my patients often produced idealisations, in their clinical material,
which seemed to be an attempt on their part to externalise, to find a
way of conceiving, thinking about, one particular aspect of their own
creations: that is, the experience of orgasm, whether genital or pre-
genital. And in this sense the idealisation was surely not deluded,
because, by definition, the orgasm is a wonderful experience. (At least
theoretically it is, although there may be many interfering factors pre-
venting it reaching that stage.) Idealisation is commonly talked about
by analysts in terms of its use as a defence against ambivalence in the
relationships to the object; my patients' material suggested that it can

also be used as a way of symbolising the genital or pregenital subjective experience of orgasm. And in this setting the concept of disillusion takes on a special meaning, especially in connection with the urge towards passivity and the blissful surrender to the body impulses (for which the word 'passivity' is perhaps really inappropriate, since it is more an active letting go). For this letting go seems to mean not only a letting go of all voluntary control of the muscles, it can also mean a letting go of the discriminating capacities which distinguish differences. Thus what patients experience as a dread of 'passivity' often turns out to be partly a dread not only of letting go the control of the sphincters, but also of a perceptual letting go, which would mean a return to an extreme of undifferentiation between all the openings of the body and their products. Thus there is a dread of the total letting go of all the excited mess, faeces, urine, vomit, saliva, noise, flatus, no one differentiated from the other, a state of blissful transcending of boundaries, which, to the conscious ego, would be identified with madness. The dread is of a wish for the return to that state of infancy in which there was no discrimination between the orgastic giving of the body products and the products themselves. I suggest that it is this original lack of discrimination which is partly responsible for the later idealisation of the body products; and the disillusion is then experienced when the real qualities of the intended love gift come to be perceived. I find clinical evidence which seems to show that, particularly in poets and artists who are inhibited in their work, there has been a catastrophic disillusion in the original discovery that their faeces are not as lively, as beautiful, as boundless, as the lovely feelings they had in the giving of them. Thus the infant's disillusion about its own omnipotence, its gradual discovery that it has not created the world by its own wishes, cannot be discussed fully without also considering its disillusion about the concrete bit of the outside world that it literally does create; that is, the infant's own body products. It follows that for patients whose fixation point is at this stage, the surrender of the consciously planning deliberative mind to the spontaneous creative force can be felt as a very dangerous undertaking; for such patients have not yet grown out of their unconscious hankering after a return to the blissful surrender to this all-out body giving of infancy.

It is part of psycho-analytic theory that, when the infant has reached the stage of recognising the loved mother as not created by the infant but as a person in her own right, from whom love is received and to whom love is to be given, then arises the problem of how the love is

to be given, how it is to be communicated. And this stage leads eventually to the need to accept a different medium for the expression of feelings from the child's own body products; and also to the need to accept the necessity for work with that medium, since the beautiful mess does not make a picture or a poem all by itself. Thus it seems to me that in the analysis of the artist (whether potential or manifest) in any patient, the crucial battle is over the 'language' of love, that is to say, ultimately, over the way in which the orgasm, or the orgastic experiences, are to be symbolised. It certainly seems that the analysis of this primary identification of the living feeling experience of the body with the non-living material produced by the body would be likely to be critical for any artist (in the wide sense), since an artist's work is essentially concerned with the giving of life to the bit of 'dead' matter of the external world which is the chosen medium. For, in a sense, what the artist idealises primarily, is his medium. He is in love with it; and this fact may also lead to difficulties through exaggerated ideas about what the medium can do. But if he loves it enough so that he submits himself to its real qualities, at the same time as imposing his will upon it, the finished product may eventually justify the idealisation.

Thus the way in which it was found possible to help patients with a fixation point at this stage was, not by interpreting to them the phantastic nature of their idealisations, not by showing them their mistake in so idealising their own body products; but by showing them that the idealisation was not a delusion, in so far as it referred to the intensity of their own orgastic sensations, it was only a delusion when they clung to the belief that the 'mess' was itself as beautiful as the feelings experienced in making it.

In the light of these considerations it became possible to see further into the meaning of the Parrot's Egg symbol. Thus the storm represents the parrot's angry disillusionment at realising the need to give up the belief that everyone must literally see in the anal product (the egg) the beautiful feelings that went to produce it; that is, at the need to give up the subjective valuation and accept the objective. Thus the battle is with the mother (Grey Lady), not only over the evaluation of the love gift, but also over what is a suitable and convenient stuff for symbols of love, love 'poems' to be made of. It seemed to me that the same theme is also elaborated in 'Queen Elizabeth and the Bashful Parrot', though with the emphasis this time on the pain of recognition that the faeces are in fact dead, for the symbol of the crosses in the background was associated with graves. The Dog-Cat picture (which

was actually drawn in black and yellow) also, I think, illustrates the
stage at which there is no differentiation between 'dead' faeces and the
'living' feelings, since the dark shapes surrounding the anus-sun take
the form of animals; that is, they are felt to be living and do in fact
(according to the associations) represent moods.

III. Infantile Prototypes of Creativity

It is basic to analytic theory that, after experience has forced us to
realise, as infants, that we have not made everything, we transfer this
belief to our parents and feel that at least they have. And then follow
all the vicissitudes of discovery round about the themes of the parents'
real physical creative powers. Some of the pain connected with these
discoveries is shown in the content of the drawing 'Ape in the Garden
of Eden'. In the main part of this book I discussed the subject of the
aggression that results from the child's jealousy of the parents' love
relation. What I did not mention was the masturbatory aspect of the
child's relation to the parents' sexual life. It is a commonplace of
psycho-analytic theory that the child has a phantasy of containing the
parents inside him, in some sort of relationship, and a relationship
which the child seeks to feel he or she can control omnipotently; and
this phantasy serves as part of the child's way of coming to deal with
the painful fact of recognising an actual dependence upon the real
parents. But this phantasy is not only intimately connected with mas-
turbation, it also seems to serve as the child's pre-verbal symbol for
thinking about its own creative capacities—at least when it has reached
the stage of becoming aware of and accepting the parents' genital
creative function, and has passed the stage of believing in an omni-
potent fiat of creation. This means that doubts about the goodness of
wishes towards the external parents, doubts about the capacity to
master such jealousy as the Angry Ape's, lead to doubts about the
goodness of the real creative forces inside itself. It certainly does seem
that in some patients the difficulty in coming to trust and have faith in
the fact of the creative forces within themselves is intimately bound up
with their unconscious conflicts over masturbation phantasies. Since
these patients often have difficulty in achieving a masturbation phan-
tasy in which they feel themselves to be conducting a benign inter-
course, they do in fact feel themselves more likely to conduct a malev-
olent one, and so they come to feel they have no reason to trust in the
goodness of the 'baby' which will result from that internal intercourse.

Clinical material suggests that the symbols used for thinking about the creative process in oneself are derived, variously, from the stages of interest in different aspects of bodily experience. It might be possible to work out in detail the kinds of symbols used at the different stages of development. Such a scheme would have to take into account, for instance, the stage at which to open one's eyes was felt to be a fiat of creation, a saying 'let there be light', which resulted in there being light; or the time when to open one's mouth was to create the nipple that filled it; or the time when the opening of one's bowels was not distinguished from the opening of one's eyes, so one really did believe one's faeces were the same as the world one saw, one felt oneself to be a dancing Siva creating the world; or the time when to masturbate was to create a heaven (or a hell) with the dance of one's own limbs. For there seems to have been a time when even the faculty of consciousness itself was felt to be entirely creative, to be aware of anything was simply to have made it; all one saw was one's own, as Traherne said, and it was one's own because one had made it. And in this setting it is Mother Nature who is the disillusioner, who seems to rob one of one's own creativity; it is nature that is responsible for the fact that one's faeces are such a small and stinking and dead bit of the world. So she can come to be felt, in certain settings, as the Blasting Witch who shrivels up the landscape; as well as the powerful but helpful Grey Lady of the Angry Parrot picture.

IV. Changes in the Sense of Self

In this book I have tried to describe how, under the particular conditions of making the free drawings, something new, unexpected did in fact emerge. The phrase 'contemplative action' had seemed an appropriate description of the process: 'contemplative' to distinguish it from practical expedient action, 'action' to distinguish it from pure contemplation, to bring in the fact of the moving hand.

The essential thing about this contemplative mood, combined with action, was that it involved me in a giving up of the wish to make an exact reproduction of anything I had seen. Since obviously one cannot anyway produce a truly realistic copy of any object known in the external world, for marks on a two-dimensional surface can never be an exact reproduction of a three-dimensional object, it would seem that this was not a very difficult wish to give up. Nevertheless, in spite of my early discovery that no attempt to copy the appearance of

objects was what my eye liked there was still a continual inner battle to be waged against the urge to attempt this mechanical copying; and this, in spite of years of experience of the fact that it was only when I had discarded this wish to copy that the resulting drawing or painting had any life in it, any of the sense of a living integrated structure existing in its own right. Of course I knew that many of the greatest artists said that they did copy nature, but I had began to doubt whether this really meant what it seemed to mean. I began to suspect that they were in fact trying to describe the process of surrendering themselves to the deep spontaneous responses of nature within them, that were stimulated by the contact with nature outside them.

I have also tried to describe how, whenever I was able to break free from the urge to make a mechanical copy and a new entity had appeared on my paper, then something else also had happened. The process always seemed to be accompanied by a feeling that the ordinary sense of self had temporarily disappeared, there had been a kind of blanking out of ordinary consciousness; even the awareness of the blanking out had gone, so that it was only afterwards, when I returned to ordinary self-consciousness, that I remembered that there had been this phase of complete lack of self-consciousness.

In considering what might be the relation between this change of consciousness, the surrender of the wish to work to a copy and the sense of an 'independent life' in the result, I was reminded of two sets of ideas. On the one hand, there was all that analysts have to say about certain kinds of changes of consciousness, described variously as states of elation, as blankness, as oceanic feeling; and, on the other hand, the blankness referred to in various mystical writings, including 'emptiness' as a beneficent state, which is, for example, the central concept in the *Tao Te Ching*.

Analysts have related experiences of this kind to the satisfied sleep of the infant at the mother's breast. Certainly such experiences, especially those to do with ecstasy and elation, can be fitted into a coherent scientific pattern by our so relating them. But may we not be missing something important if we look on them only as an end product, as a hallucinatory getting back to where we have never quite given up wanting to be? Is it not possible that blankness, lack of mindfulness, can also be the beginning of something, as the recognition of depression can be? Is it not possible that the blankness is a necessary prelude to a new integration? May not those moments be an essential recurring

phase if there is to be a new psychic creation? May they not be moments in which there is a plunge into no-differentiation, which results (if all goes well) in a re-emerging into a new division of the me-not-me, one in which there is more of the 'me' in the 'not-me', and more of the 'not-me' in the 'me'?

I do not want to enter into a discussion of which of the psychic institutions, ego, super-ego, id, can be looked upon as responsible for the vitality and 'newness' of a good free drawing, but only to bring into focus the fact that there is some force or interplay of forces creating something new, and to suggest that the way we think about it in ourselves affects the way it works. And I want to suggest the possibility that a number of states of mind that are different from everyday conscious awareness may be in part an expression of the unconscious or half conscious need to give this creativeness its freedom; they may be in part distorted forms of an essential and normal phenomenon. And perhaps some of the aggressive attitudes of children have a similar meaning. I have elsewhere* described as a holy war such attempts of people to keep in touch with this inherent creativeness, a war that is also shown, I think, in the Angry Parrot's dilemma. For it seems to me that there may be an added reason for a child's violent defence of its own spontaneity; that not only are instincts arrogant and imperious, seeking their own satisfaction as soon as possible, not only is impulsive action pleasanter and easier than waiting; but also any rigid division into twoness, into awareness of the separateness of the 'me' and the 'not-me' (even though this is essential up to a point for the practical business of living), any copying of, obedience to, an imposed plan or standard, whether inner or outer, does necessarily interfere with this primary creativeness.

V. Rhythm Relaxation and the Orgasm

Rhythm and balance were essential ideas in the associations to the drawing 'If the Sun and Moon should doubt . . .'. But the concept of rhythm presupposes a time factor, which cannot in fact be present in a drawing itself, though there is rhythm and therefore a time factor in the movements of hand and arm that make it; and also a time factor is implied in the contemplation of it, the contemplating eyes do move according to what are usually called the rhythms of the picture. A rhythm has a beginning and an end, but a picture, once it is painted,

* 'The Role of Illusion in Symbol Formation.'

does not begin anywhere or end anywhere, all its elements co-exist simultaneously; in this sense perhaps it is true to say that a picture is timeless. But whatever the linguistic difficulties of using the word rhythm to describe an ingredient in pictures, the fact remains that the concept of rhythm must be included in any attempt at verbalisation of the nature of the unconscious forces that produce a free drawing.

In the chapter on rhythm I have already discussed the idea that the inherent rhythmic capacity of the psycho-physical organism can become a source of order that is more stable than reliance on an order imposed either from outside, or by the planning conscious mind. But here our struggles to adapt, in infancy, to social living, provide a potent source for anxiety when we are trying to learn to paint; for the desire for the primitive rhythms, such as sucking, free bowel movement, babbling, masturbating, may all be reactivated when the adult sets himself the task of surrendering the conscious control of movement of the hand while still going on moving it.

The study of technique for achieving bodily relaxation has shown that release of any particular muscle is largely achieved by the apparently simple act of directing attention to it, letting consciousness suffuse it. But, in any one of us, if the need to relinquish the wish to return to the infantile phase of surrender to a total release, including the release of sphincter muscles, has not been adequately worked through, then the idea of the surrender of any muscular tension is bound to be associated with social anxiety, sometimes very acute. In this book, and also in others, I have tried to describe the observed effects of changes in body awareness and in muscular tension which resulted from different ways of focusing attention and different ways of drawing. But such phenomena clearly cannot be studied unless we also take into account that involuntary suffusing of the body with maximum intensity of feeling which goes with the experience of the orgasm. And the orgasm cannot be discussed, in the setting of the theme of this chapter, without also considering what are its symbols in non-logical thinking, how it is conceived of on the level of non-verbal imagery. The subject of the capacity to make one's attention suffuse the whole body, and the relation of this to the genital and pregenital orgasm, both as experienced and as thought about, would lead to a field of discussion beyond the scope of this book. Such discussion if undertaken would have to include a psychological study of the symbolic meaning of light and colour, subjects which have been only very briefly touched on in Chapter Four.

Clearly the subject of colour is, on the evidence of language alone, very closely bound up with the feelings. For instance, we talk of an emotional statement as a highly coloured one, and of its high points as 'purple patches'. We are 'green with envy', we 'see red', or we 'feel blue'. And the subject of light, which includes the inner light and the light of dreams is equally closely bound up with the theme of consciousness. That consciousness can in fact also suffuse the whole body, though it does not ordinarily do so, is perhaps expressed poetically by the psalmist's phrase 'clothed with light as it were with a garment'. There is also the fact that the sense of inner 'beingness', of 'dead' material acquiring life of its own, is the fundamental test of the goodness of a work of art; for a good picture is one in which every mark on the canvas is felt to be significant, to be suffused with subject. Similarly a good dancer gives the impression that there is maximum intensity of being in every particle of the living flesh and muscle and skin, the body itself having become the objective material suffused with subjectivity; and in good sculpture the whole mass of 'dead' metal or stone has been made to irradiate the sense of life.

VI. Painting and Symbols

I have said that the question of what kind of entity was produced by the method of the free drawings was not explicitly raised in the main part of this book. What kind of thing it was that appeared within the framed gap provided by the blank sheet of paper had become more clear to me when I thought more about the function of frames.

Frames can be thought of both in time as well as in space, and in other human activities besides painting. An acted play is usually, nowadays, framed by the stage, in space, and by the raising and lowering of the curtain in time. Rituals and processions are usually framed in space by barriers or by the policemen that keep back the onlookers. Dreams are framed in sleep and the material of a psycho-analytic session is framed both in space and time. And paintings, nowadays, are usually bounded by frames. But wall paintings are not, and when the wall is the wall of a cave the painted image must come nearer to the hallucinated images of dreams. Thus when there is a frame it surely serves to indicate that what's inside the frame has to be interpreted in a different way from what's outside it; for painters nowadays do not seem so concerned to achieve a near hallucination. Thus the frame

marks off an area within which what is perceived has to be taken symbolically, while what is outside the frame is taken literally. Symbolic of what? We certainly assume that it is symbolic of the feelings and ideas of whoever determined the pattern or form within the frame. We assume that it makes sense, for instance we assume that the people on the stage are not there just by accident. In the same way, as analysts, we have learnt by experience that an apparently casual remark made within the frame of the session also makes sense if understood symbolically.

I did not make much use of the word symbol in the original edition of this book. This was because I was then still confused by the classical psycho-analytical attempt to restrict the use of the word to denoting only the defensive function of symbols, to what Ernest Jones called 'pure symbolism'. But now, having in the meantime published a technical paper, based on clinical material, on the subject of symbolisation, and having come to the conclusion that I could not usefully restrict the concept in such a way, I can accept the idea that a work of art is necessarily and primarily a symbol.* Also in the first edition I talked about the role of images but did not recognise, and for the same reason, that a mental image is a symbol. Thus whereas before I could only talk about the artist as making new bottles for the continually distilled new wine of developing experience, now I could talk of him as making new symbols. I could look on the artist as creating

* There is always the difficulty, when using the word symbol in connection with art, that different writers continue to use it in different ways. I am using it here in the same sense that Susanne Langer uses it in her book *Feeling and Form*, when she says 'Art is the creation of forms symbolic of human feeling'. Thus I am not using it in the sense that Vivante does (in his book *English Poetry*) when, in writing about Blake, he says: 'Poetic expression is a moment of life and truth, but symbols are stiffened things, with the super-addition of abstract conceptions, or references to extrinsic powers and causes which are not fully realised, and lack the self-dependent, self-witnessing truth of *form*. We see sometimes in Blake's poetry *expression* overlapping in *symbols*.' I would agree with his observation about Blake but disagree with his narrow use of the word symbol. Marangoni (in *The Art of Seeing Art*) also talks about symbols; he says: 'This very form, this "language" or whatever one decides to call it, this is the very essence of art. Those lines, those surfaces, that play of light and shade, which the painters call into being are not, as many people still believe, symbols of what he wishes to express, but become through the miracle of art, a direct medium of expression of his whole spirit, become *his* art. "Art is direct expression".' Here, there is clearly more than a linguistic difference. Marangoni shows himself to be one of those who believe what Susanne Langer calls 'The widely popular doctrine that every work of art takes rise from an emotion which agitates the artist, and which is directly "expressed" in the work . . .' She adds: 'But there are usually a few philosophical critics—sometimes artists themselves—who realise that the feeling in a work of art is something the artist conceived as he created the symbolic form to present it, rather than something he was undergoing and involuntarily venting in an artistic process. There is a Wordsworth who finds that poetry is not a symptom of emotional stress, but an image of it—"emotion recollected in tranquillity".'

symbols for the life of feeling, creating ways in which the inner life may be made knowable; which, as Freud said, can only be done in terms of the outer life. And since this inner life is the life of a body, with all its complexities of rhythms, tensions, releases, movement, balance, and taking up room in space, so surely the essential thing about the symbols is that they should show in themselves, through their formal pattern, a similar theme of structural tensions and balances and release, but transfigured into a timeless visual co-existence. Thus the artist surely amongst other things that he is doing, is making available for recall and contemplation, making able to be thought about, what he feels to be the most valuable moments in this feeling life of psycho-physical experience. And in his concern for the permanence and immortality of his work, he is not only seeking to defy his own mortality (as analysts have said), he is perhaps also trying to convey something of the sense of timelessness which can accompany those moments. He does in fact make tabernacles to house the spirit, with the result that others can share in his experiences, and he himself can have a permanent record of them after the high moment of transfiguration has passed; and it may be a high moment of rage and horror and pain as well as of joy and love. So that broadly, what the painter does conceptualise in non-verbal symbols is the astounding experience of how it feels to be alive, the experience known from inside, of being a moving, living body in space, with capacities to relate oneself to other objects in space. And included in this experience of being alive is the very experiencing of the creative process* itself.

In psycho-analytic terms this process of seeking to preserve experiences can certainly be described in terms of the unconscious attempt to preserve, recreate, restore the lost object; or rather, the lost relation with the object conceived of in terms of the object. And these experiences can be lost to the inner life, not only because of unconscious aggressive feelings about separation from the outer object, but also because it is of the nature of feeling experience to be fleeting. Life goes on at such a pace that unless these experiences can be incarnated in some external form, they are inevitably lost to the reflective life. Then it is perhaps possible to say that what verbal concepts are to the conscious life of the intellect, what internal objects are to the unconscious life of instinct and phantasy, so works of art are to the

* Non-psycho-analytic writers on art use various terms to describe the creative force. For instance, Vivante talks of 'the original formation principle', and Maritain talks of 'creative subjectivity'.

conscious life of feeling; without them life would be only blindly lived, blindly endured. Hence surely it can be said that a great work of art provides us with a new concept with which to give form to, to organise, find orientation in, the life of feeling. And it is just because feelings are about something, about objects, in the psycho-analytic sense, that we can easily talk of the unconscious meaning of the thing that an artist makes as a recreation of a lost object. But I think also there is much evidence to suggest that this function of art, as restoring lost objects, is in fact secondary; and that the primary role is the 'creating' of objects, in the psycho-analytic sense, not the recreating of them. The recreating of them is part of the so-called depressive position; for the theory of the depressive position attempts to describe what happens to an infant when it has reached the stage of recognising whole external objects separate from itself, and how it deals with the guilt and sorrow about the attacks it has made in phantasy on the objects. But I think the artist is also concerned with a stage earlier than this. I think he is concerned with the achieving that very 'otherness' from oneself which alone makes any subsequent sadness at loss possible. In fact he is concerned primarily with what Adrian Stokes* calls the 'out-there-ness' of his work. Certainly for the analyst, at certain stages in analysing an artist, the importance of his work of art may be the lost object that the work re-creates; but for the artist as artist, rather than as patient, and for whoever responds to his work, I think the essential point is the new thing that he has created, the new bit of the external world that he has made significant and 'real', through endowing it with form.

VII. The Two Kinds of Thinking

Perhaps the solution of the controversy over where the deepest meaning of art lies, can only be found through a fuller understanding of the differences between the kind of thinking that makes a separation of subject from object, me from not-me, seer from seen, and the kind that does not. We know a lot about the first kind of thinking, we know its basis in the primary laws of logic, which say that a thing is what it is and not what it is not, that it cannot both be and not be. We know also that these laws of reasoning work very well for managing the inanimate material environment. We divide what we see from ourselves seeing it, and in certain contexts this works very well. But

* Adrian Stokes, *Inside Out*.

it does not work so well for understanding and managing the inner world, whether our own or other people's. For, according to formal logic, all thought which does not make the total separation between what a thing is and what it is not is irrational;* but then the whole area of symbolic expression is irrational, since the point about a symbol is that it is both itself and something else. Thus, though separation of the seer and what is seen gives a useful picture in some fields it gives a false picture in others. I think that one of the fields in which formal logic can give a false picture is aesthetics; and that the false picture is only avoided if we think about art in terms of its capacity for fusing, or con-fusing subject and object, seer and seen and then making a new division of these. By suffusing, through giving it form, the not-me objective material with the me—subjective psychic content, it makes the not-me 'real', realisable. Clearly the great difficulty in thinking logically about this problem is due to the fact that we are trying to talk about a process which stops being that process as soon as we talk about it, trying to talk about a state in which the 'me-not-me' distinction is not important, but to do so at all we have to make the distinction. But it is only, I think, in this way of looking at it that the phrase 'art creates nature' can make sense. So what the artist, or perhaps one should say, the great innovator in art, is doing, fundamentally, is not recreating in the sense of making again what has been lost (although he is doing this), but creating what is, because he is creating the power to perceive it. By continually breaking up the established familiar patterns (familiar in his particular culture and time in history) of logical common sense divisions of me-not-me, he really is creating 'nature', including human nature. And he does this by unmasking old symbols and making new ones, thus incidentally making it possible for us to see that the old symbol was a symbol; whereas before we thought the symbol was a 'reality' because we had nothing else to compare it with. In this sense he is continually destroying 'nature' and re-creating nature—which is perhaps why the depressive anxieties can so easily both inhibit and be relieved by successful creative work in the arts. And in this sense also it can be seen how invention, both in science and in the arts can be rooted in the same process. For instance, Ernest Jones in his paper on 'The Theory of Symbolism', introduced the idea that in science the process of discovery and invention consists in freeing the tendency to 'note identity

* Here I am indebted to a lecture entitled 'The Logic of Irrationality', by Harold Walsby, author of *The Domain of Ideologies*. Glasgow, Maclellan, 1947.

in difference'. He thus draws attention to the non-logical aspect of the process.

I think the Mount of Olives drawing, with the dead bones blocking the way ahead, does symbolise a blocking of this kind of non-logical thought through an excessive reliance on logical processes. Thus it seems to me that the drawing has meaning, not only in terms of the not yet worked through feelings of guilt over cannibalistic phantasies of oral incorporation; but that it also refers to the artificial keeping dead of the method of thinking which does not stay detached and apart, that expresses itself pre-eminently in the arts. By its title the drawing makes a connection with the New Testament. This is a reference to a phenomenon which had been continually in my mind while writing this book; the fact that when thinking about the kind of surrender of conscious planning experienced in making the drawings, phrases from the Gospels kept cropping up in my thoughts, such as 'Consider the lilies of the field'. 'Take no thought for the morrow . . .', 'The meek shall inherit the earth . . .'. In fact it almost seemed that on one level the symbolism of the Gospels was a kind of poetic handbook for the way in which psychic creativity works. Certainly this non-logical type of thought does depend on a willingness to forgo the usual sense of self as clear and separate and possessing a boundary. I wondered, is it possible that the teaching of the Gospels is partly to do with a logic of non-logical thought; and also that of the *Tao Te Ching*, with its opening phrase, 'The Tao of which we speak is not the real Tao'?

VIII. PAINTING AND IMITATION

I have said that I did learn to paint, in the sense that I learnt to overcome internal and external difficulties so that I could spend most of my week-ends and holidays in a group painting. For, after many years of waiting, I had finally found people to teach me who did see that the essence of painting is that every mark on the paper should be one's own, growing out of the uniqueness of one's own psycho-physical structure and experience, not a mechanical copy of the model, however skilful. Incidentally, in this connection, I showed this book to a painter who, while turning over the pages to look at the drawings said: 'That one is not you, nor that, nor that, they are unconscious copies of some picture you have seen.' I had myself recognised the obvious derivation of 'Mrs. Punch' from the Duchess in *Alice in*

Wonderland, just as the chair in 'Nursery' derived from van Gogh; and also that the design in the 'Blasting Witch' was a close unconscious copy of the design of a picture I had often seen in a friend's room. But the painter had never seen this friend's picture and it was a surprise to me that anyone could know, without having seen the 'copy', that the line of the drawing was not my own, not growing out of my own psycho-physical rhythms. Of the wavy line at the top left side of 'The Eagle and the Cave-man' he said: 'That is good, that is from you; though the shading is not, that is mannered, banal.' The point of view prompting these criticisms confirmed my growing conviction that a work of art, whatever its content, or subject, whether a recognisable scene or object or abstract pattern, must be an externalisation, through its shapes and lines and colours, of the unique psycho-physical rhythm of the person making it. Otherwise it will have no life in it whatever, for there is no other source for its life.

I also learnt to understand something about the use of colour which made the colour in the Angry Parrot seem crude. For I remembered how I had painted the original drawing with what I would now call an intellectual attitude to colour, I had *thought* what colour I wanted to put next, rather than looking quietly at the first colour I had put and listening to it, allowing it to call for what colours it needed around it, colours that grew out of its own nature. Also I became able to see the difference between a painting and a coloured drawing and became able to paint by starting with the colour masses rather than with the outlines.

IX. A Place for Absent-mindedness

The kind of thinking that does not distinguish between the seer and the seen (or perhaps we should say, the phase of thinking, for normally it seems that the two kinds alternate with each other), is certainly continually talked about by analysts under the name of phantasy. But I think it is a pity that the expressive word 'reverie' has been so largely dropped from the language of psycho-pathology, and the overworked word phantasy made to carry such a heavy burden of meaning. For the word 'reverie' does emphasise the aspect of absent-mindedness, and therefore brings in what I feel to be a very important aspect of the problem, that is, the necessity for a certain quality of protectiveness in the environment. For there are obviously many circumstances in which it is not safe to be absent-minded; it needs a setting, both

physical and mental. It requires a physical setting in which we are freed, for the time being, from the need for immediate practical expedient action; and it requires a mental setting, an attitude, both in the people around and in oneself, a tolerance of something which may at moments look very like madness. The question then arises, are we going to treat all phenomena that are often talked of under that heading as symptoms, something to be got rid of, or can we, in our so objectively-minded culture, come to recognise them as something to be used, in their right place? In our childhood we are allowed to act, move, behave, under the influence of illusions, to play 'pretend' games and even get lost in our play, feel for the moment that it is real. In adult life it is less easy to find settings where this is possible (we get other people to do the pretending, on the films and the stage), although we do find it within the framework of the analytic session as patients.

I have suggested that, just as sleep dreaming is necessary (said Freud) to preserve sleep, so both conscious and unconscious daydreaming is necessary to preserve creative being awake. Clinical psycho-analytic experience suggests that many of the impediments to going forward into living are the result of a failure of the child's environment to provide the necessary setting for such absent-mindedness. For it seems likely that, in this phase of not distinguishing the 'me' and the 'not-me' we are particularly vulnerable to the happenings in the inner life of those nearest to us emotionally.* Two of the most disturbed patients I have had, who also had marked artistic gifts, both showed attempts to cling rigidly to the laws of formal logic (although they had never heard of the explicit statement of these laws). One of them would say furiously, in response to an interpretation involving symbolism, 'But a thing either is or it isn't, it must be one thing or the other!' And the second patient would always insist that the literal meaning of any object or activity was the only possible meaning. And both of those patients had mothers who were mentally extremely ill. I suggest that such a human environment forces a child into desperate clinging to the phase of thinking that does distinguish between the 'me' and the 'not-me', because this is the only protection against an impossible confusion between their own and their parents' inner problem. But this (which is one possible meaning for the phrase 'premature ego development') leads them to great difficulties in managing their

* Maritain, in his book *Creative Intuition in Art and Poetry*, quotes Cézanne's exclamation to Ambroise Vollard: 'I damn well have to be left alone when I *meditate*'.

social environment, for they continually try to employ the kind of thinking (formal logical) which in fact gives a false picture of that world of human feeling (their own and other peoples') that they are trying to understand and manage. And the result is that whole areas of their experience become cut off from the integrative influence of reflective thinking. What they are essentially in need of is a setting in which it is safe to indulge in reverie, safe to permit a con-fusion of 'me' and 'not-me'.

Such a setting, in which it is safe to indulge in reverie, is provided for the patient in analysis, and painting likewise provides such a setting, both for the painter of the picture and for the person who looks at it.

BIBLIOGRAPHY

TO FIRST EDITION

GRAHAM BELL, *The Artist and his Public.* Hogarth Sixpenny Pamphlets, Number Five, 1939.

M. P. FOLLETT, *Creative Experience.* New York, Longmans, Green & Co., 1930.

J. GASQUET, *Cézanne.* Bernheim Jeune.

A. GILCHRIST, *The Life of William Blake.* Ed. by Ruthven Todd. Dent and Sons.

CORA GORDON, *Art for the People.* Art Education, Sept. 1939. Published by British Institute of Adult Education.

JAN GORDON, *A Step Ladder to Painting.* Faber and Faber, 1934.

JUAN GRIS, *Horizon*, Vol. XIV, 1946.

C. J. HOLMES, *Notes on the Science of Picture-Making.* Chatto and Windus, 1939.

M. L. HOURD, *The Education of the Poetic Spirit.* Heinemann, 1949.

G. SANTAYANA, *Little Essays.* Ed. Smith. Constable.

HAROLD SPEED, *The Practice and Science of Drawing.* Seeley Service and Co.

BIBLIOGRAPHY

TO SECOND EDITION

The first form of this book was written from a general background of standard psycho-analytical writings, such as the works of Freud, Ferenczi, Ernest Jones, Abraham, Ella Sharpe, Melanie Klein, Anna Freud, etc. Themes of particular relevance to the ideas expressed in the appendix are to be found in the following works:

EHRENZWEIG, ANTON. *The Psycho-Analysis of Artistic Vision and Hearing.* London, Routledge and Kegan Paul, 1953.

'The Modern Artist and the Creative Accident.' London, *The Listener*, Jan. 12, 1956.

FAIRBAIRN, W. R. D. 'Prolegomena to a Psychology of Art.' *Brit. J. of Psychol.* Vol. XXVIII, 1938.

FREUD, ANNA. 'A Connection between the States of Negativism and of Emotional Surrender.' Abstract. *Int. J. of Psycho-Anal.* Vol. XXXIII, 1952.

FREUD, SIGMUND. *The Interpretation of Dreams*, 1900. (Revised edition, Allen and Unwin, 1937, Chapter VII.)

The Origins of Psycho-Analysis. Letters to Wm. Fliess 1887–1902. London, Imago Publishing Co., 1954.

GOMBRICH, E. H. 'Psycho-Analysis and the History of Art.' Ernest Jones Lecture, 1953. *Int. J. of Psycho-Anal.* Vol. XXV, 1954.

'Meditations on a Hobby Horse, or the Roots of Artistic Form' in *Aspects of Form*, ed. L. L. Whyte. London, Lund Humphries, 1951.

JONES, ERNEST. 'The Theory of Symbolism' (1916) in *Papers on Psycho-Analysis.* London, Baillière, Tindall and Cox, 1948.

Sigmund Freud, his Life and Work. London, Hogarth Press, 1953, ff.

JUNG, C. G., and WILHELM, RICHARD. *The Secret of the Golden Flower.* London, Routledge and Kegan Paul, 1931.

KLEIN, MELANIE. 'Infantile Anxiety Situations reflected in a Work of Art and in the Creative Impulse' in *Contributions to Psycho-Analysis 1921–1945.* London, Hogarth Press, 1948.

KRIS, ERNST. *Psycho-Analytical Explorations in Art.* London, Allen and Unwin, 1953.

'Neutralisation and Sublimation' in *Psycho-Analytic Study of the Child.* Vol. X. London, Imago Publishing Co., 1955.

LANGER, SUSANNE. *Philosophy in a New Key. A study in the symbolism of Reason, Rite and Art.* Cambridge, Mass., Harvard University Press, 1942.

Feeling and Form. London, Routledge and Kegan Paul, 1953.

LEWIN, BERTRAM. *The Psycho-Analysis of Elation.* London, Hogarth Press, 1951.

MARITAIN, JACQUES. *Creative Intuition in Art and Poetry.* New York, Bollingen Foundation Inc., 1953.

MILNER, MARION. 'The Communication of Primary Sensual Experience'. *Int. J. of Psycho-Anal.* Vol. XXXVII, 1956.

'The Role of Illusion in Symbol Formation' in *New Directions in Psycho-Analysis,* edited by Melanie Klein and others. London, Tavistock Publications, 1955.

READ, HERBERT. 'Psycho-Analysis and the Problem of Aesthetic Value.' *Int. J. of Psycho-Anal.* Vol. XXXII, 1951.

'Art and the Development of Personality.' *Brit. J. of Med. Psychol.* Vol. XXV, 1952.

Icon and Idea. The Function of Art in the Development of Human Consciousness. London, Faber and Faber, 1955.

REIK, THEODOR. *The Inner Experience of a Psycho-Analyst.* London, Allen and Unwin, 1949.

SCOTT, W. CLIFFORD M. 'The Body Scheme in Psycho-Therapy.' *Brit. J. of Med. Psychol.* Vol. XXII, 1949.

SEGAL, HANNA. 'The Psycho-Analytic Approach to Aesthetics' in *New Directions in Psycho-Analysis,* edited by Melanie Klein and others.

SHARPE, ELLA. Similar and Divergent Unconscious Determinants Underlying the Sublimations of Pure Art and Pure Science, 1935.

'Psycho-Physical Problems revealed in Language; an Examination of Metaphor', 1940 in *Collected Papers on Psycho-Analysis.* London, Hogarth Press, 1950.

STOKES, ADRIAN. 'Form in Art' in *New Directions in Psycho-Analysis.* edited by Melanie Klein and others. London, Tavistock Publications, 1955.

Inside Out. London, Faber and Faber, 1947.

Smooth and Rough. London, Faber and Faber, 1951.

Michelangelo. A Study in the Nature of Art. London, Tavistock Publications, 1955.

Colour and Form. London, Faber and Faber, 1937.

VIVANTE, LEONE. *English Poetry and its contribution to the knowledge of a creative principle.* London, Faber and Faber, 1950.

WINNICOTT, D. W. 'The Child and the Family', 'The Child and the Outside World'. London, Tavistock Publications, 1957.

'Transitional Objects and Transitional Phenomena.' *Int. J. of Psycho-Anal.* Vol. XXXIV, 1953.

DESCRIPTION OF ORIGINAL DRAWINGS

Frontispiece: *The Angry Parrot*, 9 in. by 5½ in. Water-colour.

FIG.

1. *Mrs. Punch*, 18 in. by 22 in. Charcoal on brown paper.
2. *Beautiful Young Girl*, 6 in. by 10 in. Chalk (black with yellow flowers, red bag, cheeks).
3. *Summer Morning*, 5¼ in. by 4 in. Charcoal and wash (purple and blue and black).
4. *Summer Beeches*, 4½ in. by 4 in. Charcoal.
5. *Nursery*, 7½ in. by 4½ in. Charcoal and powder paint (bright red, yellow, green).
6. *Spanish Garden*, 4½ in. by 7½ in. Pencil.
7. *Milkman*, 7 in. by 5½ in. Pencil.
8. *Two Jugs*, 4½ in. by 3½ in. Pen and ink.
9. *Thunder over the Sea*, 5 in. by 4½ in. Charcoal and wash.
10. *Earth* (*a*, *b*, *c*, *d*), 4½ in. by 5½ in. Charcoal.
11. *Sea Wall* (*a*), 4½ in. by 5½ in. Pencil. (*b*), 4½ in. by 5½ in. Pen and ink.
12. *Blasting Witch*, 4 in. by 3 in. Charcoal and wash (crimson sky, emerald and sea-green and black landscape, mauve witch).
13. *Frugal Mouse*, 8 in. by 5 in. Pale chalk outlines (mauve and black mosquito, pale green and pink mouse).
14. *Innocent Donkey*, 6 in. by 8 in. Charcoal and wash (yellow donkey, sea-green grass, black water).
15. *The Demanding Bottle*, 9 in. by 7 in. Charcoal with pale chalk tinting (green, mauve, pink).
16. *Freedom*, 6 in. by 3 in. Pen and ink and pale chalk tinting (yellow, pink, green).
17. *Lamb in Wolf's Clothing*, 7 in. by 4 in. Pastel (black wolf skin, bright blue hair, red dress).
18. *Salome*, 6 in. by 4½ in. Charcoal.
19. *Macbeth and the Witches*, 4 in. by 3½ in. Charcoal and pale wash (yellow ochre, sea-green, grey).
20. *Skeleton under the Sea*, 7 in. by 5 in. Water-colour (varying tones of blue wash).
21. *Ape in the Garden of Eden*, 8 in. by 10 in. Charcoal and chalk tinting (crimson, green, yellow, blue).
22. *Comment*, 4 in. by 4 in. Pencil and chalk (red signal, green mouth, nostril, ear, beak, cheeks).
23. *The Escaping Bear*, 5 in. by 7 in. Chalk (red, yellow, black, green).
24. *Small Porgies*, 4¼ in. by 4¼ in. Chalk (black, crimson, orange, green, blue).
25. *Horrified Tadpole*, 4 in. by 5½ in. Chalk (red, yellow, black, green).

INDEX

Also available from J.P. Tarcher, Inc.
Joanna Field's first book: *A Life of One's Own*

In 1926, while still in her twenties, Joanna Field came to the awareness that she was not living a truly authentic existence. Vaguely discontented but optimistically trying to make the best of things, she was uncertain as to who she truly was or what she really wanted out of life. Finally, the realization that her life was hers alone to live and enjoy to its fullest launched her on a profound journey of self-exploration carefully charted in this charming and thoughtful book.

A Life of One's Own is a long-out-of-print classic. Though written almost fifty years ago, the book could hardly be more relevant or provide a more useful example for its modern reader. It offers, in the author's words, "a method for discovering one's true likes and dislikes, for finding and setting up a standard of values that is truly one's own and not a borrowed, mass-produced ideal."

"This is a social document of value, because there are many men and women today in exactly the same predicament as that of 'Joanna Field.' The only way in which they can achieve happiness is by a kind of rebirth, an escape from 'spiritual virginity': and this book is an account of how to the writer this rebirth was made possible."

Stephen Spender

The publication of *A Life of One's Own* in this country is a long-overdue event. Joanna Field is a woman far ahead of her time in her understanding of the dual capacities of the mind, and in her courageous self-exploration."

Charlotte Painter,
author of *Revelations: Diaries of Women*

ISBN 0-87477-193-5
$5.95